To Cousin
Dewayne;
Enjoy this rich
and wonderful history!
Anita G. Arnold
7/26/2010

IMAGES
of America

OKLAHOMA CITY MUSIC
DEEP DEUCE AND BEYOND

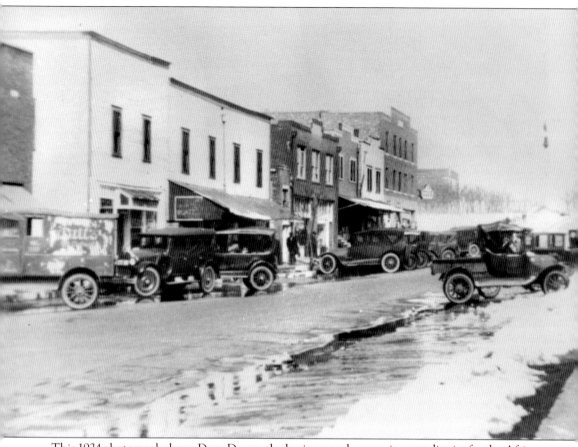

This 1924 photograph shows Deep Deuce, the business and entertainment district for the African American community in Oklahoma City for more than 60 years. Deep Deuce, the 300 block of Northeast Second Street, became legendary beginning in the 1930s when music men like Count Basie and Duke Ellington wound up in Oklahoma City and discovered a mecca of music that included the Blue Devils, Jimmy Rushing, Leslie Sheffield, the Bolars, and Charlie Christian. (Courtesy of Black Liberated Arts Center, Inc.)

ON THE COVER: T-Bone Walker, a guitar man, dancer, and singer, frequented Oklahoma City's Deep Deuce because of Charlie Christian and his band, which performed at one of the popular dance halls frequented by African Americans. Walker, who became famous after his days of playing and dancing with Christian, often boasted of their friendship and claimed to have even given Charlie his job in a band that he grew tired of playing with. (Courtesy of Black Liberated Arts Center, Inc.)

IMAGES
of America

OKLAHOMA CITY MUSIC
DEEP DEUCE AND BEYOND

Anita G. Arnold
Foreword by Charles Burton Jr.

ARCADIA
PUBLISHING

Copyright © 2010 by Anita G. Arnold
ISBN 978-0-7385-8427-0

Published by Arcadia Publishing
Charleston SC, Chicago IL, Portsmouth NH, San Francisco CA

Printed in the United States of America

Library of Congress Control Number: 2010920055

For all general information contact Arcadia Publishing at:
Telephone 843-853-2070
Fax 843-853-0044
E-mail sales@arcadiapublishing.com
For customer service and orders:
Toll-Free 1-888-313-2665

Visit us on the Internet at www.arcadiapublishing.com

CONTENTS

ACKNOWLEDGMENTS

My love for music and writing began in the 1950s when I heard the song "Ham Bone, Ham Bone" and believed I could write music. I wrote one song, "I've Got to Go to School or I'll Be a Big Fat Fool," and worked with my piano teacher, the late Alta Watson at Earlsboro, Oklahoma's Douglass Elementary School, to put music to the words. She inspired and encouraged me, and I never lost my passion.

In 1994, while researching and writing my first three cultural history books, I learned about the music history of Oklahoma City. It was exciting! Special thanks to all of the oral historians, including Leroy Parks, who helped lay the foundation for this book. I cannot thank Leo Valdes enough for the help he provided me with his 40-plus years of collecting information and photographs of Charlie Christian.

I am deeply indebted to Sharon Dean and her family, who worked tirelessly with me in getting the mountains of photographs in the right format for publication. Shannon Brown was always there to help whenever I needed her, even into the next day when required; thanks Shannon. Hats off to 88-year-old Raymond Harrison, owner of several night clubs and part owner of KAEZ Radio, and to Lilly Mae Booker, who in spite of turning 100 years old on Friday, November 13, 2009, was gracious and generous in her contributions as a socialite who danced the planks off the floor during the heyday of Deep Deuce. Others who were a great help include George Barnes, Charles Burton, Joyce Dunlap, Kirbie Greene, Marion Harkey, Eugene Jones, Harold Jones, Johan Kimbro, Morris McCraven, Charlie Nicholson, Harold Edwards, the Earl Pittman family, Ellen Sheffield, and Walter Taylor.

I wish to thank my friend William Welge, from the Oklahoma History Center, who was generous with his time and resources in making this book possible. I thank my editors Ted Gerstle and John Pearson at Arcadia Publishing, who were great in encouraging me and were very patient during a personal tragedy that took time away from the project. They were marvelous to work with.

FOREWORD

After arriving at Langston University in 1960 to begin college, I began to survey the surrounding landscape to see where I could generate some income to help my parents with expenses.

Having been a professional guitarist in the Tulsa area since the age of 15, I began to explore possibilities of work in the Oklahoma City area, about 45 miles away. At the time, the disco format did not exist, but any club or venue of any prominence had a band or live entertainment.

The Bill Parker Band, Leslie Sheffield, Preacher Smith, Dog Brown, Sonny Morrison, Leon Nelson, Leon "The Demon" Wright, Louie and Maurice Spears, Chester Thompson, George Moreland, Good Time Charlie, Larry Johnson, Clarence Griffin, and David English were just a few of the working musicians and bands in Oklahoma City at the time.

Prominent venues in the past 40 years included the Trevas Club, Bryant Center's Top Hat Club, Herbie's Supper Club, Horace's Supper Club, the Rens, and Elmer's Supper Club. These clubs and their owners enabled me to get my college degree. I am very thankful to them.

After graduating from Langston University, I was asked by John Smith, a music professor at Langston, to become a founding member of an organization, the Black Liberated Arts Center (BLAC), Inc.—a nonprofit organization devoted to keeping the black experience related to culture and entertainment alive and meaningful in the Oklahoma City area.

About 20 years ago, the writer of this book, Anita Arnold—a woman with extraordinary vision and foresight—took over as the executive director of BLAC, Inc. Since then, Anita has been at the forefront of entertainment in Oklahoma City. She has exposed our community to many entertainment events, in all genres, sponsored by BLAC, Inc. She has always had the goal of providing the best in entertainment to keep our community exposed to quality. No one in Oklahoma City is as knowledgeable of the history of black entertainment and cultural issues in this city as Anita. The Charlie Christian Jazz Festival, sponsored by BLAC, Inc., is a national event that has featured prominent entertainers such as George Benson.

This book will serve as an extraordinary documentation of relevant entertainment and cultural facts in Oklahoma City. I am proud to have been asked by Anita to write the foreword.

—Charles Burton

INTRODUCTION

Early writings about music in Oklahoma City's Deep Deuce area describe it as a grassroots movement of seedlings that, in later years, exploded on the national scene much like a launched rocket would after reaching the sky, showcasing all its many stars: some small, some bright and brilliant in its colors, some that died out too soon, and a few that continued to shine after others soon faded out. This movement began with five musicians called the Blue Devils around 1923. The Blue Devils evolved over a 10-year period from a small combo to an orchestra of 13 members that was led by at least six different leaders or managers; they started as a democratic commonwealth band where every member had a voice and shared equally in the pay.

From these humble beginnings, music was swinging from Deep Deuce to Eighteenth and Vine Streets in Kansas City and throughout the region from the 1920s to the 1930s as the Blue Devils took on the challenges of other bands that believed they were better, squaring off in the popular Battle of the Bands contest. By all accounts, the Blue Devils won. There were reasons for their consistent wins and their mighty reputation. They had a unique sound that was perfected by a focus on excellence. The fact that most members were classically trained musicians, who attended schools such as the Boston Conservatory of Music and who taught their fellow musicians what they knew, may have had much to do with their sound, precision, and reputation.

The group broke up and redefined itself many times as members started their own bands, such as Ermal "Bucket" Coleman's Pails of Rhythm, or who left to join other bands. Such was the case when Benny Moten from Kansas City lured Eddie Durham, Count Basie, and Oran "Hot Lips" Page to his band. When Moten died in 1935, Basie took over and recruited Henry "Buster" Smith, Lester Young, Leonard Chadwick, Jimmy Rushing, and Walter Page. Ultimately most of the early Blue Devils members became the Count Basie Band, but this was not the last iteration for these talented musicians. Jimmy Rushing established his own career and became famous as a blues shouter and is memorialized today in the U.S. Postal Service Black Heritage Stamp Collection. Lester Young left to form his own band, which was popular for years.

As these musical giants left the scene, others transitioned into the Blue Devils, taking their places, such as the Christian brothers, Edward and Charlie, who played briefly with the band. Leroy Parks, Abe Bolar, Buster Smith, and Ernie Williams came in and tried to keep the band going in spite of turnover. It was as if the band became a stepping stone to other things. In 1939, Blue Devils band member Charlie Christian joined the Benny Goodman Band and came into his own as a national star and eventually a jazz legend. Another Blue Devils band member, Leslie Sheffield, and his own band, the Rhythmaires, became a household name. Sheffield also composed, played, and conducted music and was the head of one of the musical families of Oklahoma City. It is said that Sheffield composed one of the songs that made Charlie Christian famous after he joined the Benny Goodman Band. The Sheffield legacy stretches over three generations, with his daughter Ellen and her daughter "Miss Muffy."

It was during this time that Zelia N. Page Breaux, daughter of Inman Page, the first president of Langston University, built her reputation as supervisor of music for the colored schools of Oklahoma City. Breaux taught music, created operettas, formed bands, did early recruitment from elementary schools for her high school bands, competed in national contests, and participated in the 1933 Chicago World's Fair. It was there that Breaux captured the attention of many, including Duke Ellington, who began trips to Oklahoma City to perform, visit, and perhaps discover new talent for his band. Eventually Ellington came back to the funeral of his dear friend Zelia Breaux at the invitation of Earl Pittman, a prominent educator and bandleader.

Breaux was an excellent businesswoman, as demonstrated by her partnership with Fred Whitlow in the ownership of the Aldridge Theater. The theater served as a movie house, as well as a venue for blues and jazz concerts and for traveling minstrel and vaudeville shows. Breaux allowed the Blue Devils to provide music during the showing of silent movie films.

Breaux continued to develop musicians throughout her school-teaching years. One of her well-known students was Evelyn LaRue Pittman, who eventually had her own interdenominational choir that she continuously traveled with throughout Europe for a number of years. Pittman was a noteworthy composer and conductor with her own radio show during those times. Earl Cornelius Pittman was another of Breaux's students that carried the music banner in Oklahoma City during the 1950s as a teacher of string instruments who was a major influence on generations of musicians that migrated to national stages.

On the national level, Deep Deuce, also known as "Deep 2" or "Deep Second," located on the 300 block of Northeast Second Street, became as famous in music and entertainment circles as it was in business circles. It was business by day and entertainment by night for the black community, separated from the white community by segregation and all of its ugliness. Despite being surrounded by the hard realities of the law, African Americans created their own entertainment and outlets for that entertainment. To those who lived there, and to those who knew of it, Deep Deuce was a music mecca, complete with supper clubs, after-hours spots, Slaughter's Dance Hall, the Aldridge Theater, and churches—all great venues for music. Beyond the Deep Deuce, the schools were alive with music and music programs.

During the 1940s until the late 1960s, students were required to take music or music appreciation before graduating from high school; no student was left untouched by music in the black schools. There were all kinds of choirs in schools and churches. There were choirs that developed in the schools but evolved into community choirs, as was the case of the Messiah Choir. It had roots at Douglass High School, a school known for excellence in all its undertakings as evidenced by numerous trophies from all kinds of competitions, including music.

It was 1970 when John Smith, the first black member of the Oklahoma City Symphony, founded Black Liberated Arts Center (BLAC), Inc. to fill the arts void at Douglass High School that was created when the state took arts out of the schools. The organization provided music through concerts and via the Charlie Christian International Music Festival.

Individuals continued to explore their musical abilities, including Isaac and Johnnie Kimbro, Roosevelt Turner, and Chester Thompson, who composed and played with Tower of Power and Carlos Santa. There were crooners, high school rock-'n'-roll, and doo-wop groups such as the Dukes and the Uptown Syndicate, whose members left Oklahoma City following graduation. Some remained as others moved on to become stars at night in other cities and countries. Those who remained included Preacher Smith, who had perfect pitch and who could only play in one key; the Clarence Griffin Band; Sonny Morrison and the Soul Messengers; and the ever-popular Burton Band. Among those well-known bands that enjoyed popularity during the 1970s and 1980s and eventually recorded their music are Bottom Line Transaction, After Five, and Shortt Dogg.

Development of music venues continued inside and outside of the black community as the city grew and integration slowly took place. Nightclubs, supper clubs, dance halls, schools, and churches became plentiful. Many dances were annual events, but in between these pseudo-balls there were other occasions for music. There were breakfast dances, all kinds of parades (including funeral parades), barbecues, house parties, jam sessions, and so much more.

Each generation of musicians had their own "voices of music" and influences that spoke of and supported them in so many ways. Earlier generations had native son and prize-winning author Ralph Ellison, who spoke for Deep Deuce and its musicians, particularly Charlie Christian and Jimmy Rushing. Roscoe Dunjee, editor of the *Black Dispatch* newspaper, made his comments on the music scene, its famous musicians, and most musical events, whether it was a parade, a funeral, or a dance. A constant awareness of what was happening in music and in the social whirl was provided by Jimmy Stewart in his regular column "Jimmy Says" and by Edward Christian in the *Black Dispatch*. Radio voices that informed the community included early radio host Clayborn White, followed by Ben Tipton and so many more, when Raymond Harrison, Jesse Robinson, and Jimmy Miller became owners of the first black-owned radio station in Oklahoma City. Some of the popular voices on that station included Al Wiggins, Chris Arnold, and Fred Elkins. Wiggins and Arnold moved from Oklahoma City to other states, where they excelled in their respective fields of movie acting, recording music, teaching, and, in the case of Arnold, sports casting and producing his own national television show, *On the Beam*.

As the beat goes on with the Oklahoma City music scene, new faces appear with excellent talent, and the choice they made positions themselves for greater things. Among those coming along is songstress Donna Cox, who is adept at singing any kind of music, including classical, gospel, jazz, and blues. Cox is working on her Ph.D. at Columbia University in New York City but is beloved by the Oklahoma City community. Young Jaymes Kirksey played at Carnegie Hall at age 16. Tyrone Stanley, a talented artist who has remarkable singing skills and plays the organ and keyboards, has made a name for himself in Oklahoma City and New York City. Barbara and Charles Burton, owners and founders of Diamond Recording Studio, provide one of the finest music-recording studios anywhere. It attracts national artists such as Kanye West, whose family members are natives of Oklahoma City and were among those who experienced Deep Deuce during its heyday. Indeed the beat goes on!

One

BLUES SHOUTING
AND ALL THAT JAZZ

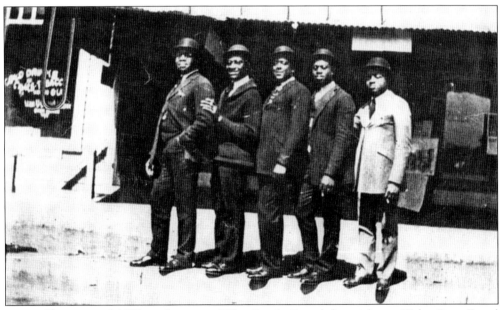

Pictured here around 1925 are the original Blue Devils. From left to right are Walter Page, Ermal Coleman, Edward McNeil, Lawrence Williams, and William C. Lewis. Upon hearing this group play, Count Basie could not believe the sound he heard, and from that day forward all he ever wanted was to become a Blue Devil. Their motto was "All for one and one for all." Pianist Willie Lewis and bassist Walter Page attended college. Ed McNeil was a highly respected drummer who died at age 35. Trombonist Ermal Coleman, the oldest of the Blue Devils, was an army veteran who earned a living as a dance musician. Years later, the Blue Devils were inducted into the Oklahoma Jazz Hall of Fame. (Courtesy of the Earl Pittman family.)

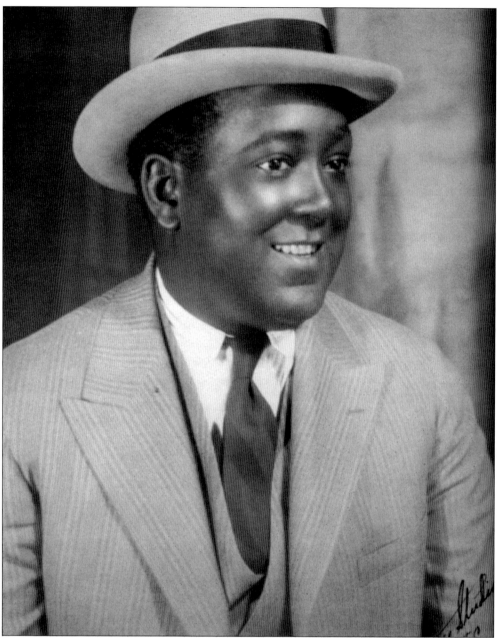

Edward "Crack" McNeil was a Kansas City musician who also played in Andy Kirk's Clouds of Joy. He had a national reputation among drummers as an expert. He married Bernice Burnett, daughter of a local grocer and sister-in-law of Earl Cornelius Pittman. Four years later, after playing at Slaughter's Hall, he slumped over unconscious and died later at St. Anthony's Hospital at the age of 35 of acute myocarditis. It was just about the time that swing was about to become popular in the United States. McNeil was a founding member of the Blue Devils. Edward Christian challenged musicians to pay their respects to McNeil by showing up to do whatever was needed for his funeral. Christian described McNeil as one of the best friends musicians had. (Courtesy of the Earl Pittman family.)

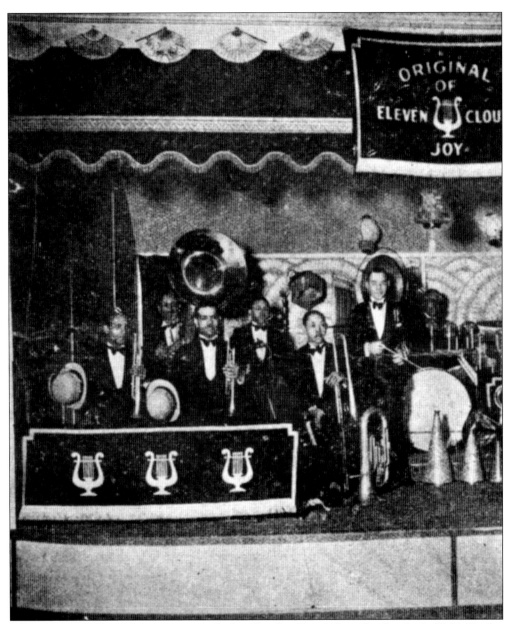

Edward McNeil (far right) is shown with the Clouds of Joy, believed to be Andy Kirk's Twelve Clouds of Joy. The banner in the photograph indicates 11 band members but an actual count reveals 12 (5 are off camera to the right). The band started as Terry Holder's Dark Clouds of Joy, and Andy Kirk was elected the bandleader after Holder left. The Clouds of Joy later featured Mary Williams as pianist and became the second Kansas City band, following Benny Moten's Kansas City Orchestra, to achieve national status. Apparently McNeil spent less than a year playing with Andy Kirk's Clouds of Joy because he left and returned to Oklahoma City in 1928. It is not clear if music became a part-time endeavor for McNeil. According to Belvy Lewis, a local aficionado of music, the Clouds of Joy played popular music and gospel. (Courtesy of the Earl Pittman family.)

Born in Missouri in 1900, Walter Page's musical background includes religious and neighborhood influences, where neighbors taught him to play bass horn. In school he was a bass drummer. After graduating from Lincoln High School, while at Kansas University, Page (at left) studied sax, violin, piano, voice, composition, and arranging. During World War I, he was a chief musician. After the war, Page played with Bennie Moten before joining the Blue Devils as their leader. Largely responsible for the unique sound of the Blue Devils, which made the group sound like twice their actual number, he moved the band from a combo to a full-fledged swing band. Count Basie came to Oklahoma and recruited Page and Jack Washington, a saxophone player, for his band in 1935. Washington is pictured below with his wife, Maphelle. (Both courtesy of Black Liberated Arts Center, Inc.)

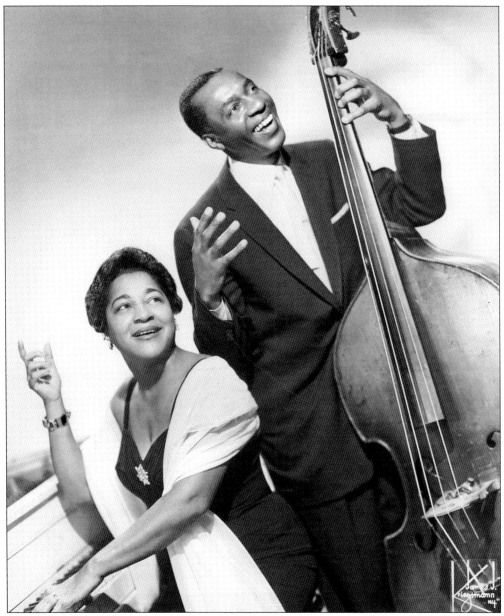

Abe Bolar was born on March 3, 1908, in Oklahoma City and started playing bass at the age of 14 in Guthrie, Oklahoma. A few years later, he became a professional and moved to Oklahoma City to join the Blue Devils. Abe later sat in as a substitute for Walter Page in the Count Basie Band. His wife, Juanita, was a pianist. Although the couple lived in New York City for more than 20 years, they were remembered and cherished by the folks on Deep Deuce. Bolar became well known in New York as a sideman who played with Lucky Millender during the 1940s and was a freelancer at recording sessions. It was his long stint with the combo formed with Benton Heath at the New Gardens Club that accounted for his longevity in the Big Apple. (Courtesy of Gloria D. Hall.)

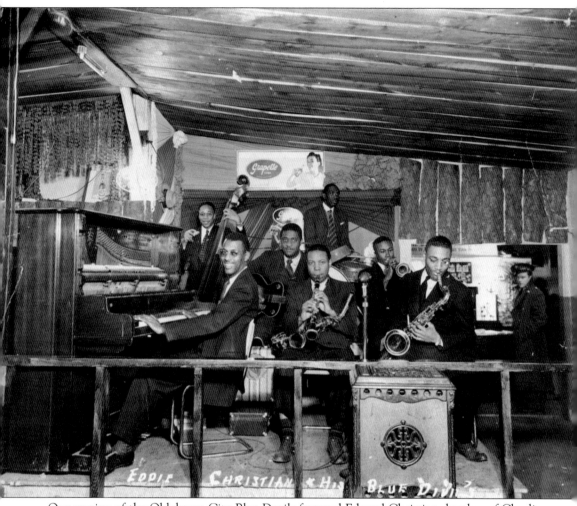

One version of the Oklahoma City Blue Devils featured Edward Christian, brother of Charlie Christian, as the bandleader. Pictured here are Wesley Simms (drums), Carl White (bass), Jim Dodson (guitar), Charles Young (trumpet), Edward Christian (piano), Harold "Cy" Cannon (alto saxophone), and Leroy Parks (tenor saxophone). The photograph was taken at the 330 Club at 300 West California Avenue in Oklahoma City. Eddie Christian was one of two voices of music during the heyday of jazz and blues. His column in the *Black Dispatch* was frequently read by those most interested in what was happening in entertainment. Charles Young is remembered for his exceptional music skills, but his life was cut short after he was stabbed during an engagement and bled to death because he did not get to the hospital in time. Leroy Parks formed his own band but eventually left music. He later established a reputation as a successful businessman. (Courtesy of Black Liberated Arts Center, Inc.)

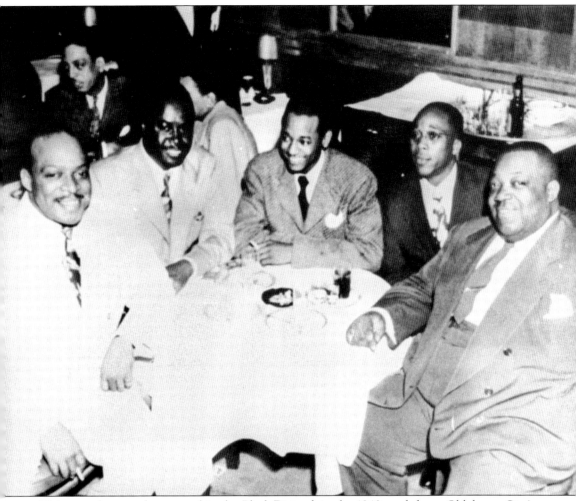

This rare photograph appeared in the *Black Dispatch* in the 1940s and shows Oklahoma City's iconic son and a legendary son together during one of the many visits they made to the Deep Deuce. Shown from left to right are Count Basie, Ernie Fields (a Tulsa-based trombonist and bandleader), Melvin Moore (a vocalist with Ernie Fields's band), Charlie Christian, and Jimmy Rushing, who was a vocalist with the Count Basie Band at the time of this photograph. Rushing became known as the world's greatest blues shouter and is memorialized in the U.S. Postal Service Black History Stamp Collection. Of all of the famous musicians during the music heyday of Oklahoma City's Second Street area, Rushing is the only one who had his own band and who established a career as a solo artist. Rushing was remembered at home for his generosity. Christian gained an international reputation in the field of guitar music and will always be remembered in history for his contribution as the first to introduce the single-string solo on the electric guitar. (Courtesy of Black Liberated Arts Center, Inc.)

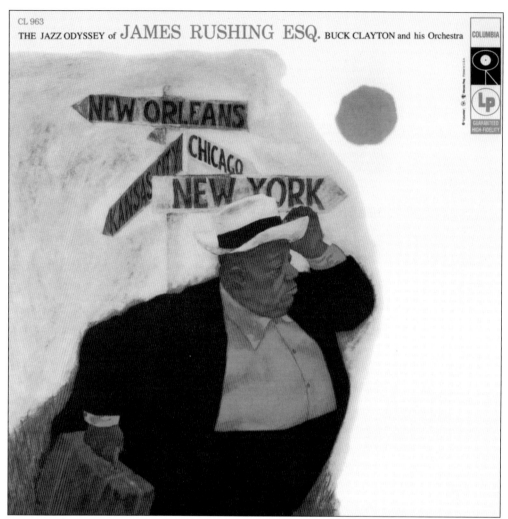

CL 963

THE JAZZ ODYSSEY of JAMES RUSHING ESQ. BUCK CLAYTON and his Orchestra COLUMBIA

James Andrew "Jimmy" Rushing was born in Oklahoma City's Deep Deuce area in 1901 to Mr. and Mrs. Andrew Rushing. Rushing was a member of one of the musical families of Deep Second. His father was a trumpeter, and his mother and two brothers were vocalists. The blues shouter and swing jazz singer was a member of Walter Page's Blue Devils in 1927 and was a vocalist for the Benny Moten and Count Basie Bands before moving out on his own as a vocalist with other bands, including Duke Ellington and Benny Goodman. He was a proponent of the Kansas City jump blues tradition. Jimmy is shown here on the album cover *The Jazz Odyssey of James Rushing, ESQ.* with the Buck Clayton Orchestra. On this album he is heard bellowing, "I'm Gonna Move to the Outskirts of Town," a popular tune in the jump blues tradition. (Courtesy of Charlie Nicholson, Charlie's Jazz Rhythm and Blues Store.)

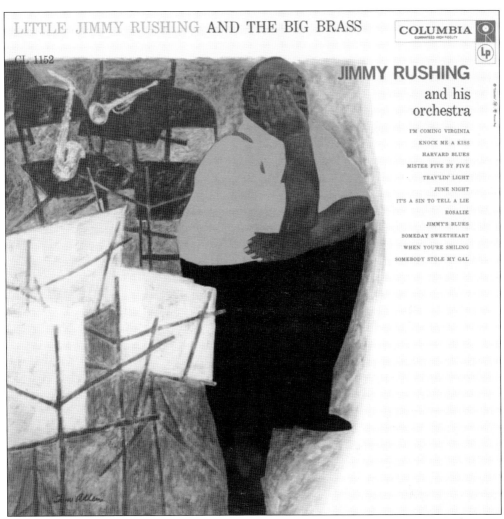

LITTLE JIMMY RUSHING AND THE BIG BRASS

COLUMBIA
GUARANTEED HIGH FIDELITY

Lp

CL 1152

JIMMY RUSHING
and his
orchestra

I'M COMING VIRGINIA
KNOCK ME A KISS
HARVARD BLUES
MISTER FIVE BY FIVE
TRAV'LIN' LIGHT
JUNE NIGHT
IT'S A SIN TO TELL A LIE
ROSALIE
JIMMY'S BLUES
SOMEDAY SWEETHEART
WHEN YOU'RE SMILING
SOMEBODY STOLE MY GAL

Jimmy Rushing was also known as "Mr. Five by Five," and his signature song "Mr. Five by Five" appropriately described his mammoth size, as being 5 feet tall and 5 feet wide. Rushing was well known for his voice range. He could go from baritone to tenor, and it was said that he could be heard above the horn and reed sections of a big band. He sings his signature song on the album pictured here. Rushing was revered around the world as a great blues singer. Germany was one of several countries that put him at the top of its list as a singer. Rushing was *Downbeat Magazine*'s "Best Male Singer" in 1958, 1959, 1960, and 1972. Rushing became ill in 1971 and was admitted to Flower and Fifth Avenue Hospital, where he was diagnosed with leukemia. He died on June 8, 1972, and is buried at Maple Grove Cemetery in the Kew Gardens neighborhood of Queens, New York. (Courtesy of Charlie Nichols, Charlie's Jazz, Rhythm and Blues Store.)

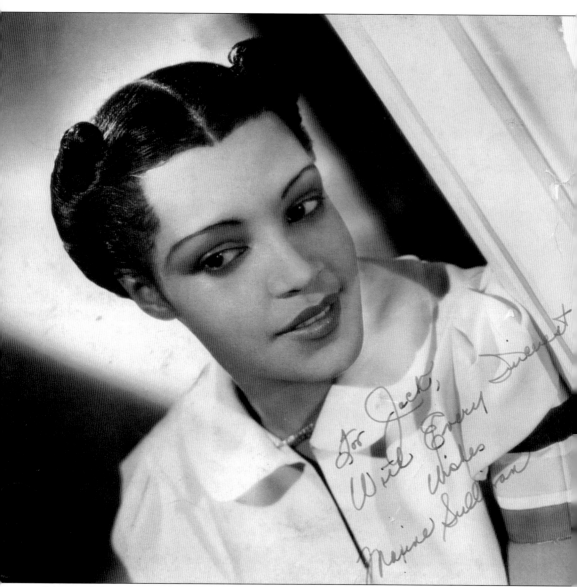

Maxine Sullivan was a famous New York City singer who started out in after-hours clubs. The child star sang her first hit in 1937 and received Grammy nominations in 1982, 1985, and 1986. Sullivan knew Oklahomans Jack Washington and Charlie Christian. As a regular on the nightclub circuit, she may have known Juanita and Able Bolar, who were regulars in New York nightclubs. It was in a 1985 interview with Leonard Feather that Sullivan recalled the moment that launched her famous career. Referring to her appearance on Broadway with Louis Armstrong and Benny Goodman in *Swinging the Dream*, a jazz adaptation of Shakespeare's *A Midsummer Night's Dream*, she said, "There was an incredible cast with the Dandridge sisters, Moms Mabley, Pearl Bailey's brother, Bill, the dancer, and in boxes above either side of the stage, we had the Benny Goodman sextet with Charlie Christian and Bud Freeman's Summa Cum Laude Band." The Oklahoma connections were at the top of their game. (Courtesy of Black Liberated Arts Center, Inc.)

Two

THE MAKING OF AN ICON

Charles Henry "Charlie" Christian was born on July 29, 1916, in Bonham, Texas, and moved with his family to Oklahoma City at the age of three. This early photograph of Charlie and his blind father's dog, Chubby (just out of view on the right), was taken shortly after moving to Oklahoma City in 1919. The family lived close to Deep Deuce. It was the same area where the 14-year-old Charlie first met Margretta Christian, the mother of his only child, Billie Jean. As teenagers, Margretta thought he was "really cute" and that he could really play baseball. (Courtesy of Black Liberated Arts Center, Inc.)

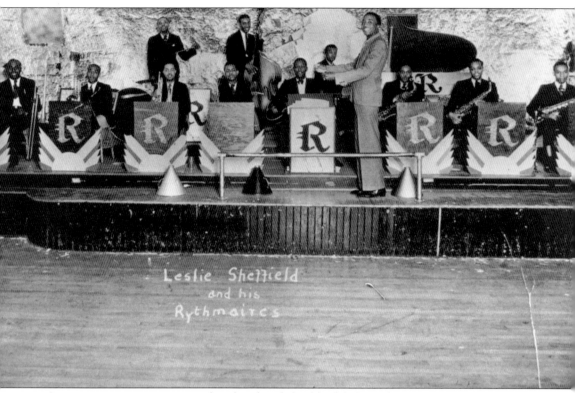

Starting as a street musician, who played with his blind father, Clarence, and his two brothers to help support the family, Charlie Christian began sitting in and playing with local combos at an early age. He later played with established bands that toured the region, including stops in Iowa, Nebraska, Illinois, North Dakota, and Texas with bands such as the Alphonso Trent Band, Annie Mae Winbun's Cotton Club Boys, a group that James Simpson's put together, and Leonard Chadwick's Rhythmaires, later known as Leslie Sheffield's Rhythmaires. Charlie is seen in this photograph with Leslie Sheffield and his Rhythmaires at age 19 at the Ritz Ballroom in Oklahoma City. From left to right are Ardis Bryant (trombone), Charlie "Little Dog" Johnson (trumpet), Nathaniel "Monk" McFay (drums), Mike Jones (trumpet), Carl Smith (trumpet), Abe Bolar (bass), Charlie Christian (guitar), Leslie "Spooks" Sheffield (piano), Charlie Waterford (director), and three unidentified saxophone players. (Courtesy of Leo Valdes.)

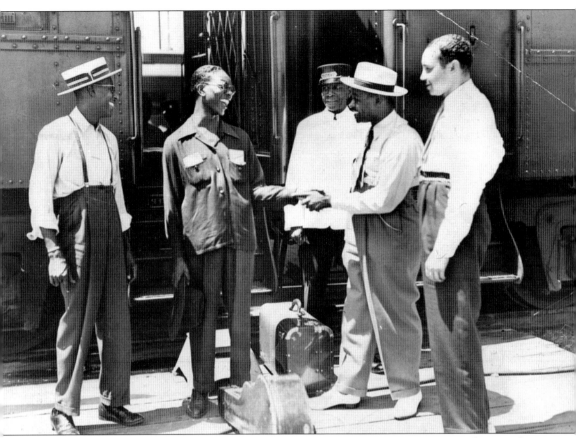

Headed for greatness, Charlie Christian left Oklahoma City on August 14, 1939, to audition with Benny Goodman in Los Angeles on August 16. At age 23, Christian had already earned a national reputation as a musician who was an incredible guitarist with a unique "horn like" sound on the electric guitar. After consistent encouragement from Mary Lou Williams, John Hammond, a talent scout and brother-in-law of Benny Goodman, made a 20-hour trip from New York to Oklahoma City on his way to California to hear Christian play. Hammond reflected later in an article that, after listening for an hour, he was determined to place Charlie Christian with Benny Goodman, primarily as a spark for the depleted Goodman quartet. That spark blazed its way to greatness in two and a half years, creating a legacy that will be remembered as long as electric guitars are made. (Courtesy of Black Liberated Arts Center, Inc.)

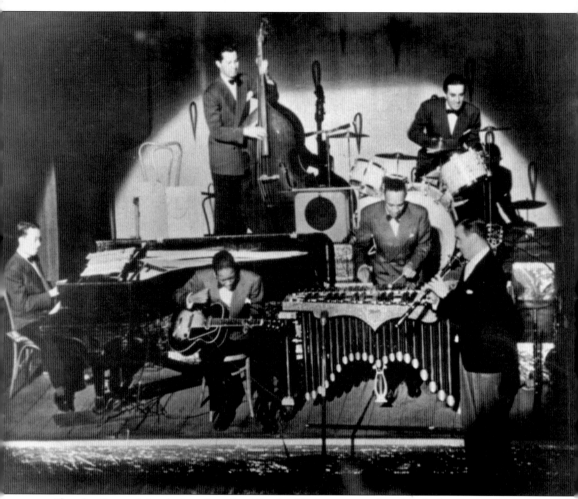

Shortly after arriving in Los Angeles, Charlie Christian was placed with the Benny Goodman Sextet. This arrangement followed Christian's amazing debut with Benny Goodman at the nightclub Victor Hugo in Beverly Hills. At the club, Charlie's solo in the first song, "Rose Room," stretched from 3 minutes into 45 minutes. According to John Hammond, band members' race was an ongoing concern at the Victor Hugo because Goodman already had two blacks in his band when Charlie Christian joined. Because of Christian's masterful and creative performances on the electric guitar, the issue quickly subsided. Pictured in December 1939 is the Benny Goodman Sextet. From left to right are Johnny Guarmiere (piano), Charlie Christian (guitar), Artie Bernstein (bass), Lionel Hampton (vibes), Nick Fatool (drums), and Benny Goodman (clarinet). (Courtesy of Leo Valdes.)

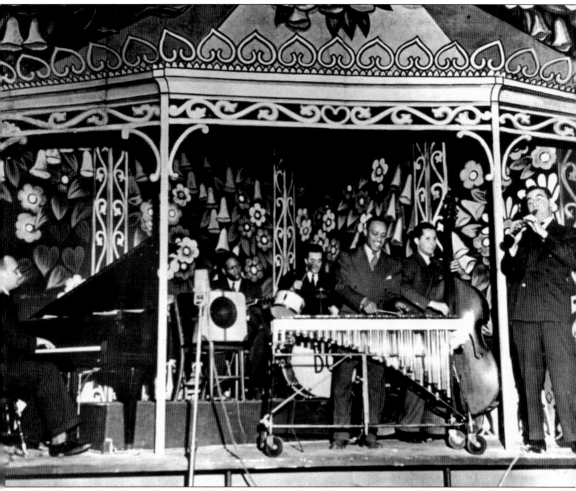

The Benny Goodman Sextet made the big time when the group appeared in New York with Maxine Sullivan on Broadway in the hit musical *Swingin' the Dream*. It was just the beginning for Charlie Christian. In New York, whenever Christian was in town, he became one of the regulars at Teddy Hill's Minton's Playhouse, an after-hours club where soon-to-be-famous musicians jammed until the wee hours of the morning. Among the rising stars were Lena Horn, Teddy Wilson, Kenny Clarke, and Thelonius Monk. Columbia Studios was another place in the "Big Apple" that Christian frequented during the many recording sessions that Goodman arranged. This rare photograph, taken at dress rehearsal at the Center Theater in Radio City Music Hall, shows Fletcher Henderson (piano), Charlie Christian (guitar), Nick Fatool (drums), Lionel Hampton (vibes), Artie Bernstein (bass), and Benny Goodman (clarinet). It was taken by Roland Harvey of *PIC Magazine*. (Courtesy of Leo Valdes.)

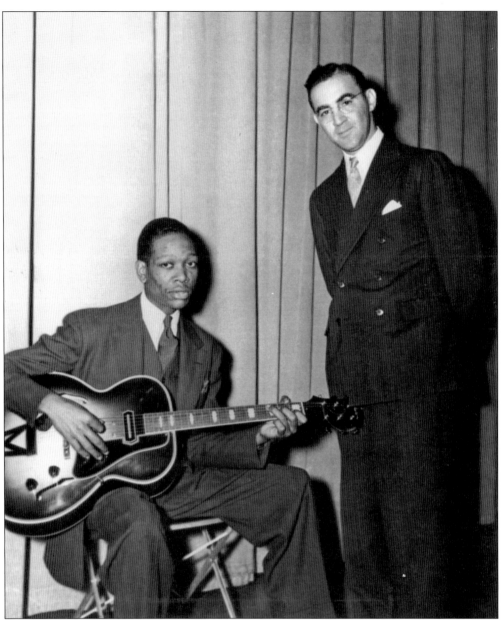

In a matter of months, Charlie Christian had popularized the Gibson ES-250, 150, and L7 guitars. By 1941, Christian and the Benny Goodman Sextet were posing in advertisements for Adams Hats. The popularity of all of the musical groupings that Goodman put together was evident by the increased sales these companies enjoyed. The one common denominator in all of Goodman's groups was Charlie Christian. The young Oklahoman, who was always stylish in photographs, would later be remembered as having introduced the single-string solo on the electric guitar and is credited with having defined the electric guitar. Wes Montgomery said, "I don't care what instrument a cat played, if he didn't understand and feel the things Charlie Christian was doing, he was a pretty poor musician." Christian (left) is pictured with Benny Goodman and his Gibson-E250. The photograph was featured on the cover of the March 1982 special commemorative issue of *Guitar Player* magazine. (Courtesy of Leo Valdes.)

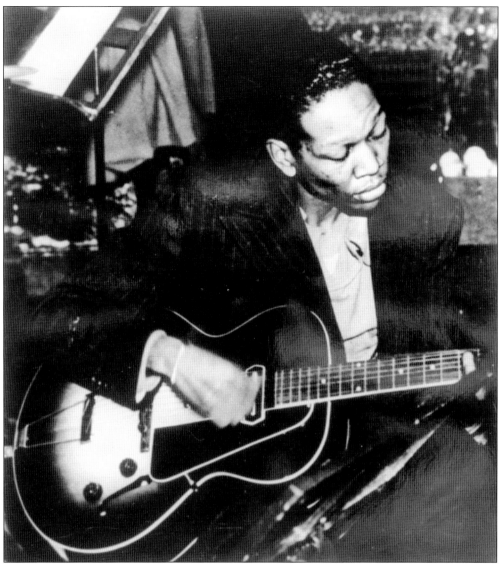

Beginning in 1939, *Metronome Magazine* put together and recorded the Metronome All-Stars Sessions featuring readers' poll winners. Charlie Christian joined the Benny Goodman Band just in time to be included in the February 7, 1940, recording session of the Metronome All-Stars Session Nine at Columbia Studios in New York City. In fact, Goodman learned almost immediately after Christian joined his band that he was good at setting riffs. John Hammond, Goodman's talent scout, said that Charlie was the best setter of riffs in swing history. Clearly the Benny Goodman Sextet was the winner of the poll that took place during the six-month period since Christian left Oklahoma City. Charlie is caught by the camera as he plays the "All Star Strut" at his first all-stars session. He is playing the Gibson ES-150 model electric guitar. (Courtesy of Leo Valdes.)

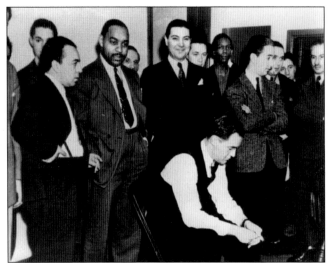

Following the 1940 recording session of the Metronome All-Stars at Columbia Studios in New York City, the Benny Goodman Sextet listens to a playback. Standing from left to right are Leonard Feather, Toots Mondello, Benny Carter, unidentified, Jack Teagarden, unidentified, Charlie Christian, Eddie Miller, Charles Spivak, and two unidentified; Benny Goodman is seated; Charlie Barner and Gene Krupa are just out of view, respectively, on the left. (Courtesy of Leo Valdes.)

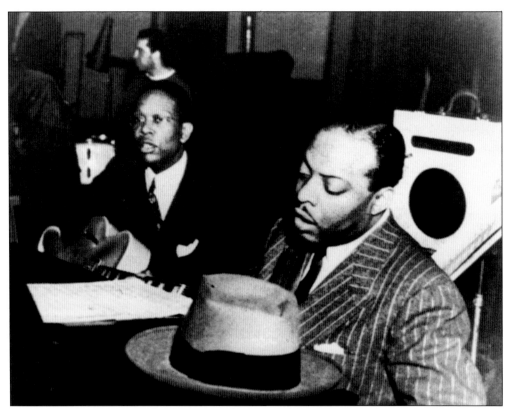

During Charlie Christian's brief career at the national level, he was selected twice to record in the Metronome All-Stars Session. His last session, called One O'Clock Jump/Bugle Call Rag, was at Victor Studios in January 1941. The session included Charlie Christian, Benny Goodman, Harry James, Buddy Rich, Cootie Williams, Tommy Dorsey, Benny Carter, Coleman Hawkins, Count Basie, Artie Bernstine, Tex Bencke, Toots Mondella, Ziggy Elman, and J. C. Higgenbottom. Charlie Christian (left) and Count Basie are shown here. (Courtesy of Leo Valdes.)

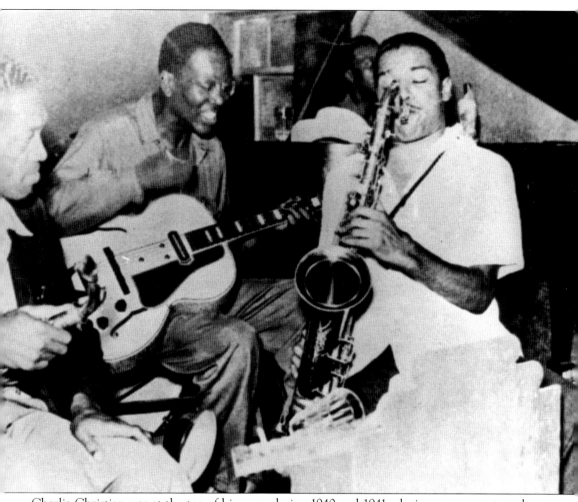

Charlie Christian was at the top of his game during 1940 and 1941, playing engagements and sitting in on numerous recording sessions in New York City. He managed to come back home on occasion. The summer of 1940 was one of the times he returned to his roots on Deep Deuce. Christian always contacted his musician friends to see what was happening. Whatever was going on, there was always time for a jam session at one of the favorite spots in the Deuce. In this photograph, taken at Ruby's Grill, one of the more popular upscale places for music and dinner, a subdued Charlie Christian jams with local musicians Sam Hughes (alto saxophone), Dick Wilson (tenor sax), and bandleader Leslie Sheffield (piano). This was likely the last time Christian came back to Oklahoma City before his early death at the age of 25. (Courtesy of Black Liberated Arts Center, Inc.)

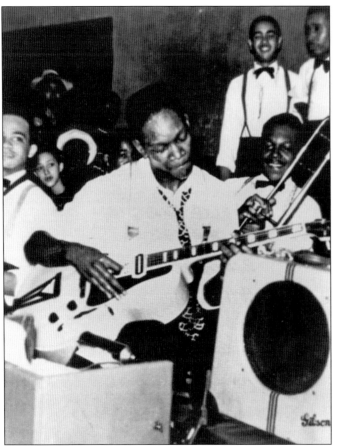

Making his way back to New York, Charlie stopped in Kansas City, where he had friends that he jammed and played with in the popular "Battle of the Bands" competition. Having established a solid reputation with Benny Goodman in less than a year, he had experiences that many musicians were still dreaming of. Apparently Kansas City was ready for Charlie. He sat in on an engagement with the Harlan Leonard Band at Lincoln Hall during the summer of 1940. Christian (at left) works hard with the band. Following the workout, a sweaty Charlie (below) stands with the "cats." From left to right are Fred Beckett (trombone), Charlie Christian (guitar), William Smith (trumpet), Henry Bridges (tenor sax), and Effergee Ware (guitar). (Both courtesy of Leo Valdes.)

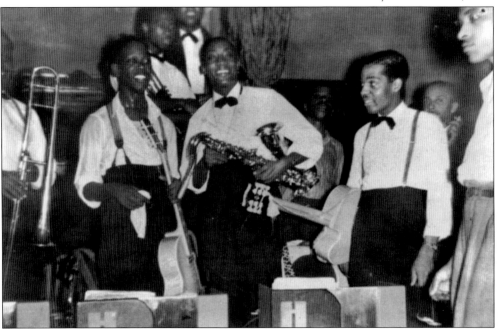

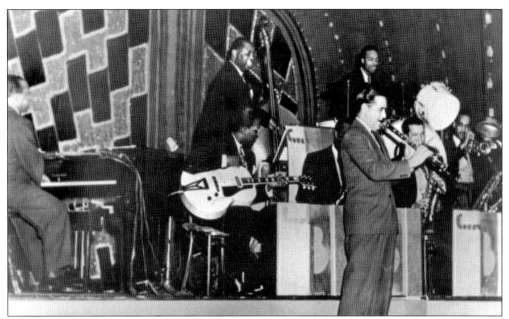

Back in New York for the next year, Charlie Christian was busy in and out of recording studios, composing tunes, playing engagements around New York City, jamming at Minton's at night, and traveling with the Benny Goodman Orchestra and Benny Goodman Sextet. The photograph above was taken of Charlie Christian and Benny Goodman sitting in with the Count Basie Orchestra at the Apollo Theater on October 24, 1940. From left to right are Count Basie (piano), Charlie Christian (guitar), Walter Page (bass), Benny Goodman (clarinet), Jo Jones (drums), Earl Warren (alto sax), and Buck Clayton (trumpet). From April 11 through April 28, 1941, the Benny Goodman Sextet appeared at the Paramount Theater in New York City. Below, from left to right, are Georgie Auld (tenor sax), Benny Goodman (clarinet), Charlie Christian (guitar), Artie Bernstein (bass), and Cootie Williams (trumpet); off camera are Johnny Guarniere (piano) and an unidentified drummer. (Both courtesy of Leo Valdes.)

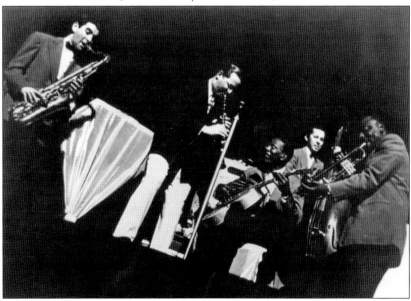

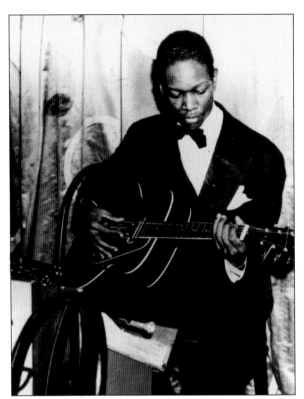

Charlie Christian played endlessly from August 14, 1939, until June 14, 1941. He got so sick during a performance in Sandusky, Ohio, that he had to leave the stage. During his 21-month, 14-day career, he had recorded no less than 30 songs, traveled all over the United States, and played in all of the famous places in Hollywood and New York City. He had secured his place in history without knowing it. This amazingly talented musician went into Esoteric Records in New York City and recorded one side of a 78-rpm record with four songs on it, "Upon on Teddy's Hill," "Guy's Got to Go," "On With Charlie Christian," and "Down on Teddy's Hill." (At left, courtesy of Leo Valdes; below, courtesy of Charlie's Jazz, Rhythm, and Blues Store.)

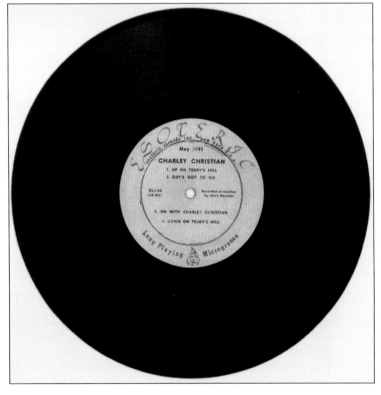

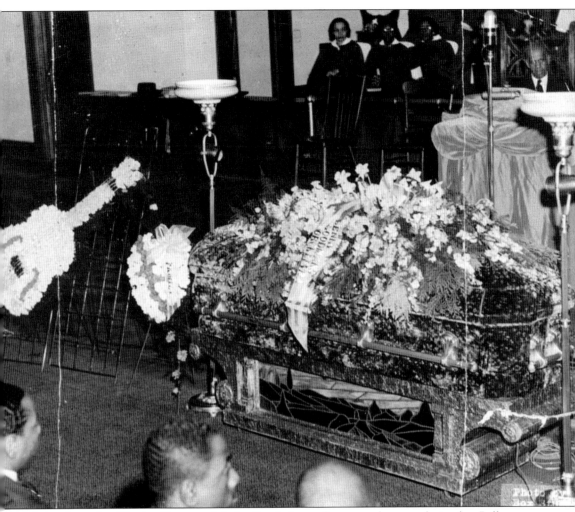

A few days after Charlie Christian left the Sandusky performance, he was admitted to Bellevue Hospital, where he was diagnosed with tuberculosis. On Friday, July 11, 1941, he was transferred to Seaview Hospital on Staten Island, New York, where he died on March 2, 1942. His body was shipped back to Oklahoma City for funeral services at 2:00 p.m. on March 9, 1942, at Calvary Baptist Church, located in the Deep Deuce area; simultaneous services were held in Chicago and New York City. Bandleaders led their bands from Deep Deuce up the hill to the church in a traditional New Orleans–style funeral parade honoring their friend. The Blue Devils' Charles Young read the obituary, and the Douglass High School Band, under the direction of Zelia N. Page Breaux, did a selection. Other musicians served as pallbearers, including Carl White, Leslie Sheffield, Wesley Simms, T. B. Thomas, Wallace Thomas, James Bowler, and Louis Diggs. Rev. A. M. Johnson, the founding minister of Calvary Baptist Church, delivered the funeral oration. (Courtesy of Black Liberated Arts Center, Inc.)

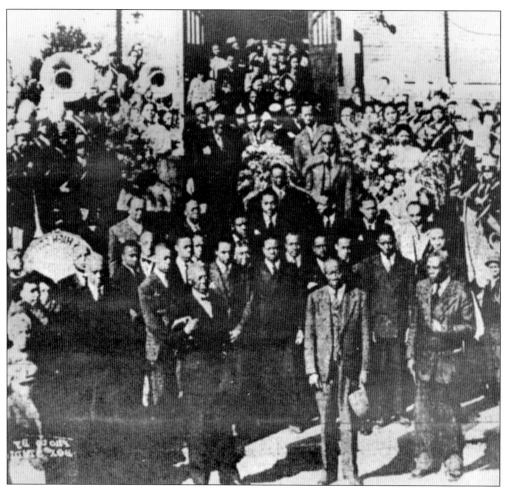

A picture taken outside the church immediately after the funeral services for Charles Henry Christian shows some of the bands with their instruments on the steps of the church (upper left). This photograph appeared in Roscoe Dunjee's *Black Dispatch* with the caption, "Taps Sound for Charlie Christian." Christian was laid to rest a few days later following final services at Bethlehem Baptist Church in Bonham, Texas, where he was buried next to "Mama" Ella George, Charlie Christian's grandmother, in the cemetery across the street from his aunt's house. For more than 52 years, only a simple grave marker stood at his grave. After conducting a national fund-raiser, Black Liberated Arts Center, Inc. dedicated a headstone for Christian's grave with a ceremony that included band performances and remembrances on April 23, 1994. (Courtesy of Black Liberated Arts Center, Inc.)

Three

IT GOES WITH THE MUSIC

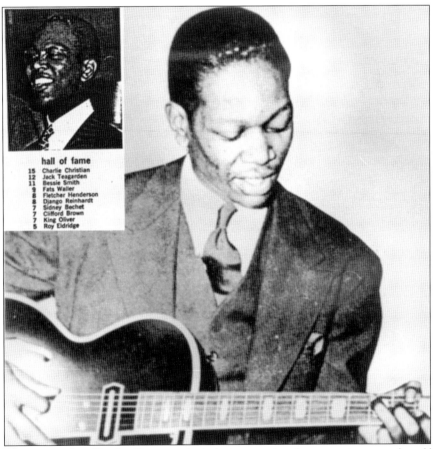

hall of fame
15 Charlie Christian
12 Jack Teagarden
11 Bessie Smith
9 Fats Waller
8 Fletcher Henderson
8 Django Reinhardt
7 Sidney Bechet
7 Clifford Brown
7 King Oliver
5 Roy Eldridge

Twenty-four years after Charlie Christian died, the international community remembered him by naming him to the International Jazz Critics Hall of Fame that was founded in 1909. The inset shows Christian at the top of the list of 10 from a poll that escalated him to this place of honor. The list also includes Belgium guitarist Django Reinhardt, who would be honored along with Christian for other prestigious awards. The honor and recognition made the August 25, 1966, cover of *Downbeat Magazine*, the respected voice of music that was founded by Albert Lipschultz in 1934 in Chicago, Illinois. (Courtesy of Leo Vales.)

nesuhi ertegun jazz hall of fame

INDUCTION CEREMONY
OCTOBER 19, 2007
DIZZY'S CLUB *COCA-COLA*

Charlie Christian was inducted into the Nesuhi Ertegun Jazz Hall of Fame at the Lincoln Center in New York City on October 19, 2007, in an impressive ceremony in Dizzy's Club Coca-Cola at the center, named for trumpeter Dizzy Gillespie. Django Reinhardt was honored along with Christian. The program cover is shown on the left. Below, the inside page of the program reflects the list of the international voting panel representing the 16 countries that unanimously voted Christian into the world's most prestigious jazz hall of fame. Anita Arnold, executive director of Black Liberated Arts Center, Inc. in Oklahoma City, accepted the impressive crystal, diamond-embedded award on behalf of Charlie Christian posthumously. (Both courtesy of Black Liberated Arts Center, Inc.)

International Voting Panel

United States
Richard Allen
George Avakian
Jean Bach
David Baker
Stanley Crouch
Michael Cuscuna*
Francis Davis
Frank Driggs
Gerald Early
Will Friedwald
Ira Gitler
Marty Grosz
Nat Hentoff
Dick Hyman
Dr. Michael James
Willard Jenkins
Orrin Keepnews
Randall Kline
Wynton Marsalis*
Marian McPartland
Dan Morgenstern*
Albert Murray*
Hank O'Neal
Doug Ramsey
Phil Schaap*
Gunther Schuller*
Loren Schoenberg*
Richard Sudhalter

John Szwed
George Wein*
Jerry Wexler
Dr. Michael G. White

Austria
Heinz Czadek

Belgium
Sjef Hoefsmit

Canada
Andrew Homzy

Chile
Jose Hosiasson

Denmark
Frank Büchmann-Møller

Finland
Jyri-Jussi Rekinen

France
Phillippe Baudoin
Phillippe Carles
Daniel Richard

Germany
Wolfgang Dauner
Gundrun Endress
Wolfram Knauer

Japan
Koji Awaya
Kiyoshi Koyama

Netherlands
Cees Schrama
Bert Vuijsje

Norway
Jan Evensmo

Poland
Pawel Brodowski

Sweden
Bo Sherman

Switzerland
Claude Nobs

United Kingdom
Brian Priestley
Chris Sheridan
Robert S. Wilber

* member of Nominating Committee

The Lincoln Center honors musicians inducted into the jazz hall of fame by playing their music. The music of guitarists Charlie Christian and Django Reinhardt was played by guitarists Russell Malone, Bobby Broom, and Biréli Lagrène in the concert hall at Lincoln Center on May 2 and May 3, 2008. The concert series of honorees is shown on the right. Below, Charlie Christian's image is captured as it appears in the hall of fame. By 2007, he had been inducted into every major music hall of fame in America, including the Rock and Roll Hall of Fame, the Oklahoma Jazz Hall of Fame, and the Oklahoma Music Hall of Fame. (Both courtesy of Black Liberated Arts Center, Inc.)

Hall of Fame Concert Series

The Nesuhi Ertegun Jazz Hall of Fame celebrates the virtuosity, integrity, and timeless classics of the giants of jazz. Join us as we swing in the spirit of our Hall of Fame members.

October 19-20, 2007
Benny Carter Centennial
Rose Theater
8:00 pm

He was the King. King of the alto sax and the trumpet. King of the Swing Era composers and arrangers. King of the Hollywood soundtrack. The Jazz at Lincoln Center Orchestra with Wynton Marsalis swings the music and arrangements of Benny Carter like "When Lights are Low" and "All of Me" with all the stomp and circumstance due jazz royalty.

January 11-12, 2008
Kings of Crescent City
Rose Theater
8:00 pm

Let *les bon temps rouler!* Jazz at Lincoln Center Orchestra reedman Victor Goines and a front line of hard-swinging New Orleans sons – featuring Wycliffe Gordon, Herlin Riley, and "Papa" Don Vappie – let the good times roll in the tradition of Hall of Famers Louis Armstrong, Jelly Roll Morton, and Sidney Bechet.

May 2-3, 2008
Django Reinhardt & Charlie Christian: Celebration of the Jazz Guitar
Rose Theater
8:00 pm

Join guitarists Russell Malone, Bobby Broom, and Biréli Lagrène and a rhythm section powered by drummer Lewis Nash as they celebrate two giants of the jazz guitar – one a Gypsy, the other wielding a new-fangled electric – who forever changed the way the instrument was swung.

For tickets, visit www.jalc.org or call CenterCharge at 212-721-6500

Dizzy's Club *Coca-Cola*
October 16-21, 2007
Celebrate the spirit of Clifford Brown with the Nicholas Payton Quintet, featuring Nicholas Payton, trumpet; Kevin Hays, piano; Vicente Archer, bass; Marcus Gilmore, drums; Daniel Sadownick, percussion.
- Call 212-258-9595 for reservations

Jazz at Lincoln Center's
Nesuhi Ertegun Jazz Hall of Fame

Frederick P. Rose Hall
Home of Jazz at Lincoln Center
Broadway at 60th Street

www.jalc.org

Hours:

Sun 10am-10:30pm
Tue-Thu 10am-11:30pm
Fri-Sat 10am-1am

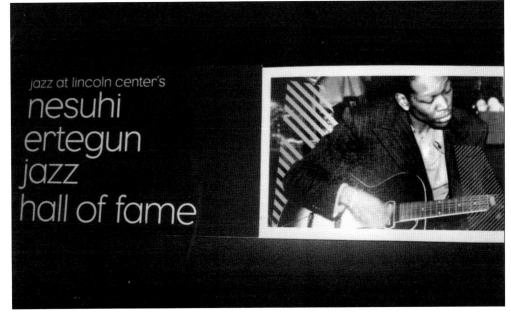

jazz at lincoln center's
nesuhi
ertegun
jazz
hall of fame

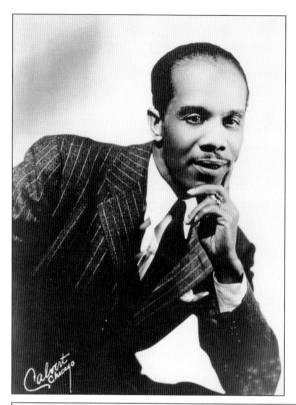

Christian was known as the "Father of Bebop" for popularizing the single-string solo on the electric guitar. He was influenced by bandleader Lester Young and guitarist Jim "Daddy" Walker of Clarence Love's Big Ten Orchestra. Love (at left) was born in Muskogee, Oklahoma, on January 25, 1908, and moved to Kansas City at age 4. He formed the Darlings of Rhythm, the first all-girls orchestra, and later formed his own orchestra bearing his name. According to Bob Blumenthal in the *Musician* magazine dated October 1980, Charlie Christian credited guitarist Jim "Daddy" Walker as his inspiration. Others claim Christian was influenced by tenor saxophonist Lester Young, who played with the Blue Devils under the leadership of Walter Page in 1932 and with Charlie during the 1940s. Christian's guitar sound was described as "horn like." (At left, courtesy of Zethel Chamberlain; below, Black Liberated Arts Center, Inc.)

LESTER YOUNG AND CHARLIE CHRISTIAN 1939-1940

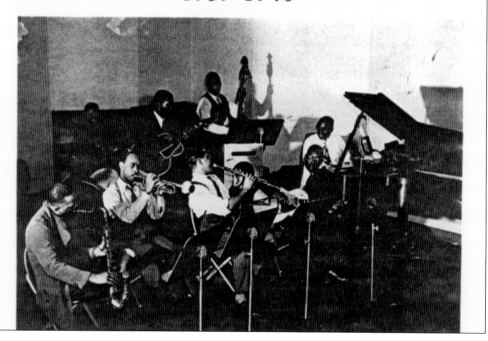

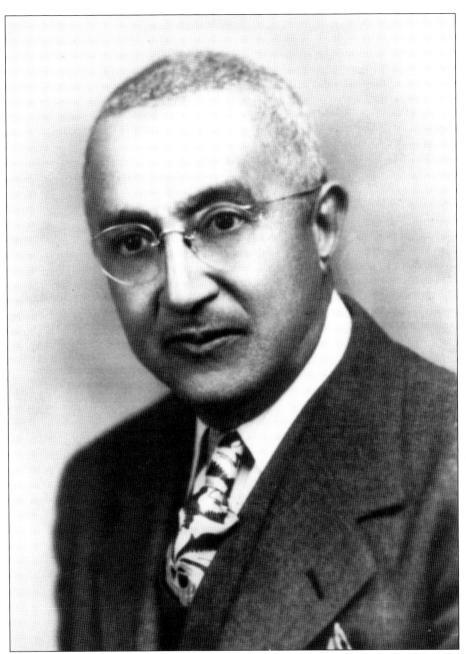

Roscoe Dunjee, respected owner and editor of the *Black Dispatch* located at 324 Northeast Second Street in the heart of Deep 2, once said, "Oklahoma is the hub of the universe and Oklahoma City is the center of the hub." Dunjee was the voice of Oklahoma City's Deep Deuce, and he had plenty to say about everything that impacted African Americans in the city from 1915 until the mid-20th century. Frequently he commented in his newspaper and publicly about Charlie Christian, Jimmy Rushing, and their friends. Dunjee loved music and often spoke at places where music was a significant part of the program. He recorded Deep Deuce's music history better than anyone during his time. More than just archiving the history, he lived and participated in it. This photograph was taken in the late 1940s. (Courtesy of the Oklahoma Historical Society.)

Jimmy Stewart (left) and Edward Christian, disciples of Roscoe Dunjee of the *Black Dispatch*, wrote weekly columns in the *Black Dispatch* on music and entertainment in Oklahoma City. Stewart's society column, "Jimmy Says," gave a rundown on what was happening on the music scene in and out of town. Stewart knew all of the musicians and local and traveling bands that performed at the Aldridge Theater or at any of the dance halls; he reported on all of it. He poses here during an Oklahoma City visit with his good friend, prize-winning author Ralph Ellison (center). Also pictured is Herbert Ellison (right), the brother of the author and a grade-school classmate of Charlie Christian. Ralph Ellison, the national voice of Deep Deuce and his friends Jimmy Rushing and Charlie Christian, wrote about both musicians in his book *Shadow and Act* and in *Saturday Review* magazine. (Courtesy of the Oklahoma Historical Society.)

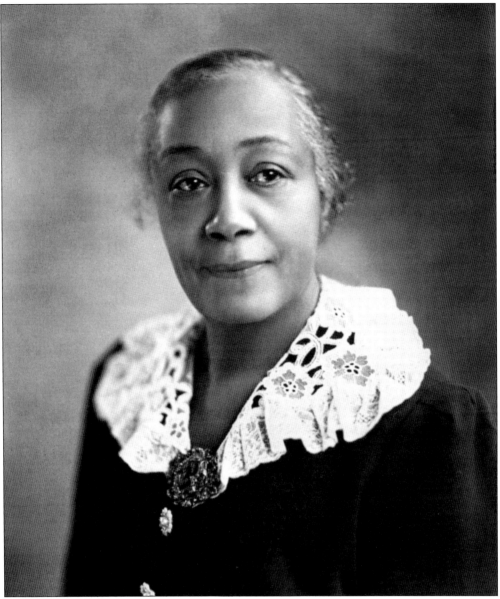

Zelia Page Breaux (1880–1956) was a pioneer in early black school music. She came to Oklahoma in 1898 with her father, Inman E. Page, the first president of Langston University. In 1918, she became supervisor of music for the black public schools of Oklahoma City until she retired in 1948. At Douglass High School, she established and directed choirs, bands, and an orchestra. Her bands were well known and performed out of state—even during the Great Depression. In 1931, they played at the Elks Convention in Denver, and in 1933 they performed at the Chicago World's Fair, where she caught the attention of Duke Ellington. In 1936, her band participated in the Texas Centennial in Dallas. She was instrumental in establishing the annual state choral and band festivals for black high school students. Some of her famous students included Edward and Charles Christian, Ralph Ellison, Jimmy Rushing, and Bernard "Step" "Buddy" Anderson. Breaux was known for identifying future band students by visiting elementary schools and encouraging talented ones to study music. (Courtesy of the Oklahoma Historical Society.)

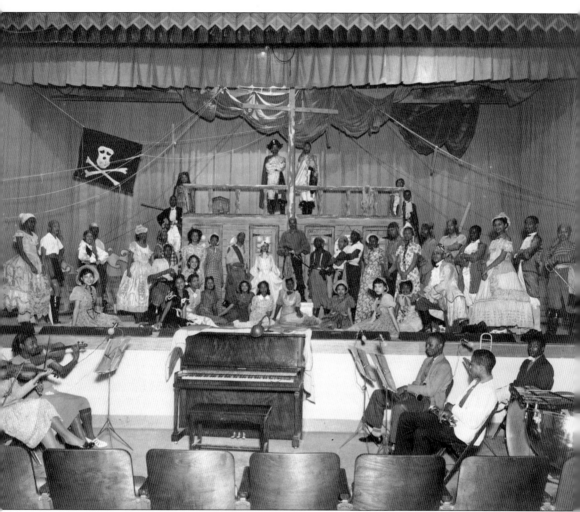

This operetta scene with accompanying orchestra members was taken in the auditorium of Douglass High School, located at Northeast Fifth and High Streets. This was one of Zelia Breaux's many musical programs performed each year for a number of years. The photograph was taken during the late 1940s or early 1950s. Two of Breaux's music students, Evelyn LaRue Pittman and Cornelius Pittman (not related), followed in her footsteps and taught classical music in the schools. Evelyn became well known locally and worked on the national and international stages with her operas and choirs. Zelia's early musical achievements include launching the school's first high school band in 1923–1924. The band included Henry P. Butler, Edward Christian, and Lawrence Williams, who ultimately joined the Blue Devils. Butler and Christian became well-known bandleaders in Oklahoma City's Deep Deuce music history. (Courtesy of the Oklahoma Historical Society.)

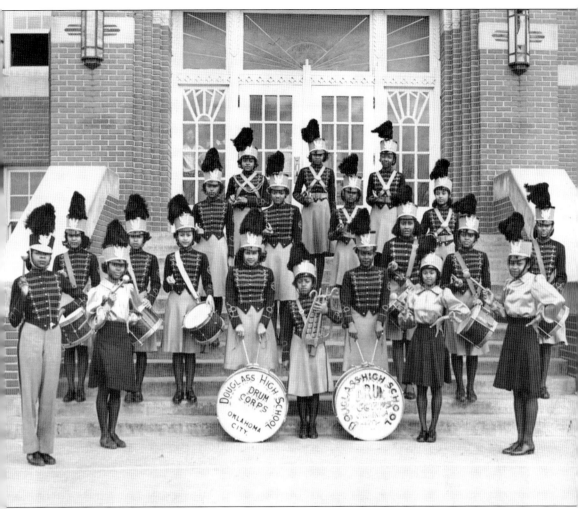

According to Bernard "Step" "Buddy" Anderson, a student of Zelia Breaux, she was a "wonderful music teacher . . . a giant . . . she played trumpet, violin, piano, and their accompaniments." Earl Pittman, another of Breaux's students, agreed with Anderson. Pittman said she was, by far, the most talented teacher there was. She had impact; she created and established all kinds of musical organizations. Juanita Harris, whose father was considered the builder of Second Street, said everyone had to take music, even if it was no more than a music appreciation course. Harris remembered having to know many of the great classical composers and conductors to pass her tests. Pittman was the one who invited Duke Ellington to Breaux's funeral, and "the Duke" came. Pictured is the all-girls Douglass High School Drum Corps that was established by Breaux. The photograph was taken on the south steps of Douglass High School during the early 1950s. The members were part of the Douglass High School parades on Deep Deuce that preceded football games. (Courtesy of the Oklahoma Historical Society.)

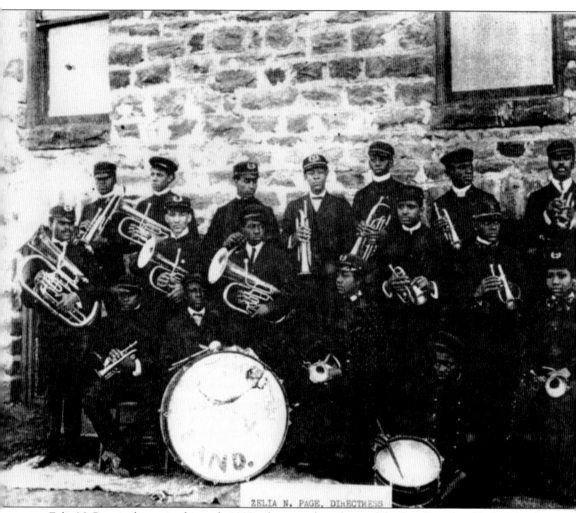

ZELIA N. PAGE, DIRECTRESS

Zelia N. Page is shown in this early-1920s photograph in front of the first Douglass High School, located on East California Avenue, with her all-male high school band. Page also served as a musical advisor for many churches and clubs in a four-state area. In 1952, the famous Zelia Page Breaux was named chairwoman of the music committee for the national NAACP convention after Jimmy Stewart persuaded NAACP officials to come to Oklahoma City. Stewart was president of the local NAACP chapter and was on the board of directors of the national NAACP. The committee was asked to furnish music for the convention. In 1983, Breaux was posthumously inducted into the Oklahoma Women's Hall of Fame and the Oklahoma Bandmasters Hall of Fame, and in 1991 she was inducted into the Oklahoma Music Educators Association Hall of Fame. (Courtesy of the Oklahoma Historical Society.)

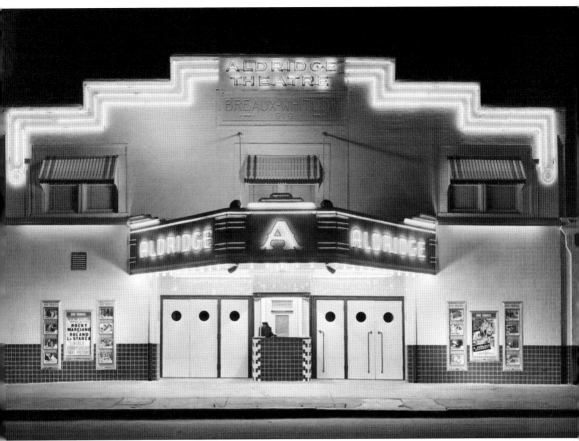

Zelia Page Breaux and Ernest Whitlow were business partners in the ownership of the Aldridge Theater from 1919 until the mid-1950s on Deep Deuce. It stood diagonally across from the Littlepage Hotel, the home of the Blue Devils when they were in town. The Aldridge was a movie house that doubled as a performing-arts venue and was one of the more popular venues on Second Street. When vaudeville shows, minstrel shows, or big names such as Ma Rainey, Bessie Smith, King Oliver's Band, Ida Cox, or Mamie Smith came to Oklahoma City, Breaux hosted these professionals at the Aldridge. Charlie Christian and Jimmy Rushing, who lived next door, performed at the theater. Although jazz music was not allowed in the public schools of Oklahoma City, Breaux encouraged musicians that played in Oklahoma City by making her resources available to them. This photograph is a night shot of the Aldridge taken in the late 1920s. (Courtesy of the Oklahoma Historical Society.)

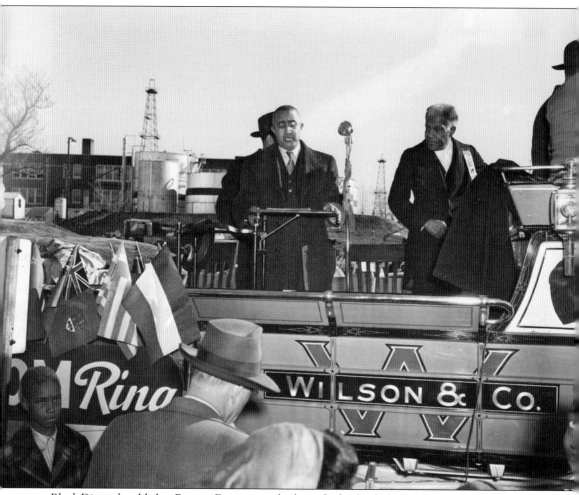

Black Dispatch publisher Roscoe Dunjee speaks from the back of a horse-drawn carriage at a 1942 rally on Second Street in support of the military servicemen during World War II. Dunjee, a lifelong bachelor who mostly received his education from an expansive library left to him by his father, was well known for his oratorical and political skills. The south side of Douglass High School, located on Northeast Fifth and High Streets, can be seen in the background; oil derricks can be seen south of the school. Oil was still king in the business world of Oklahoma City. Rallies and parades were cultural events that took place during the heyday of Deep 2. All events included music from one of the area's popular bands or from Douglass High School. This photograph is from the Myers Photo Shop collection. (Courtesy of the Oklahoma Historical Society.)

Evelyn LaRue Pittman was born in 1910 in McAlester, Oklahoma. She attended public schools in Oklahoma City. Pittman would later collaborate with Zelia Breaux on operettas and other community programs. An author, composer, choral director, producer, and music educator, Evelyn attended Spelman College and Oklahoma University, where she received her master's degree. She studied under Nadia Boulanger in Paris and Fontainebleau, France, upon the recommendation of her composition teacher, Harrison Kerr of the University of Oklahoma. Evelyn was likely the first black Oklahoman to study at the Juilliard School in New York. *Rich Heritage*, written by Pittman, was published in 1944 and updated in 1968. It is a book for children filled with biographical sketches and songs about famous black Americans. She was known for her choral arrangements of spirituals, and her major works were musical dramas. Her folk opera *Cousin Esther* was performed in Paris in 1957. *Freedom Child*, an opera about Dr. Martin Luther King Jr., was written by Pittman and was first presented in Atlanta by her own Woodlands High School students from Hartsdale, New York. (Courtesy of the Evelyn Pittman family.)

Pittman studied violin, trombone, and harmony. She received a life certificate from Langston University to teach music and social studies in the state of Oklahoma. She continued her studies at Columbia University, where she received a permanent certificate from the New York Education Department to teach public school music on any level. She taught in Oklahoma City Public Schools and moved to New York, where she lived for 20 years. In New York, Pittman studied composition with Robert Ward at the Juilliard School of Music and taught in the Greenburg School District. Her published works include "Any How," "Rock-a-mah Soul," "Sit Down Servant," "Joshua," "Nobody Knows the Trouble I See, and "Tramping," published by Carl Fisher, Inc. This photograph was taken in 1953. (Courtesy of the Evelyn Pittman family.)

Isaac Kimbro, a student of Zelia Breaux, sang with the Evelyn Pittman Choir and her Interdenominational Choir. The above photograph was taken in April 1956 in Oklahoma City; Kimbro is featured as a soloist. In fact, he sang with his sister Evelyn in everything she did. Kimbro, with his sensational bass/baritone voice, sang everywhere in the community, attracting large crowds at weddings, funerals, concerts, teas, conferences, conventions, and productions, like the ones Evelyn Pittman produced from the late 1930s into the 1980s. Kimbro and his wife, Johnnie Mae, became united in music when they married on December 25, 1949. The photographer snapped a picture of Isaac and Johnnie Kimbro at their wedding reception in the home of her parents, Lonnie and Minnie Johnson, at 803 Northeast Ninth Street in Oklahoma City. (Both courtesy of the Isaac Kimbro family.)

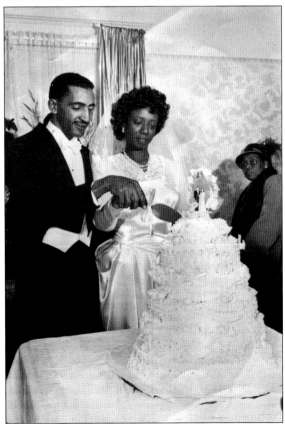

Just prior to graduation from Howard University in 1944, where she majored in music, Johnnie Mae Johnson entered a music contest that promised the winner an all-expense paid trip to New York City to perform at the famous Apollo Theater. Considered a brilliant musician, she won the contest. Little did she know that vibraphonist Lionel Hampton was in the audience. After seeing her perform, Hampton immediately offered her a job touring with his band. She accepted and toured with him for several years before returning to Oklahoma City. Later she and Ike Kimbro would return to New York City to appear on the *Ed Sullivan Show*. Johnnie Mae became a celebrated piano teacher in Oklahoma City when she was not performing with Ike and his sister Evelyn. Johnnie (far right) is seen with the Howard University Choir at Howard University's Performing Arts Auditorium in Washington, D.C., in April 1944. (Courtesy of the Isaac Kimbro family.)

Cornelius Earl Pittman, born on October 5, 1914, in St. Louis, Missouri, came to Oklahoma City in 1934. He studied music at Douglass High School under Zelia Breaux. While serving in World War II, he joined the U.S. Navy Band. Pittman later studied music at several universities, including the Ludwig Music Conservatory, and he received a master's degree in teaching from Oklahoma's Central State University in 1958. He taught in Oklahoma City public schools for 31 years. This educator, bandleader, promoter, producer, and noted classical conductor influenced and encouraged local students to pursue music as a career. One of his accomplishments occurred in 1954 when he produced the Y-Circus Variety Show with guest Duke Ellington and his orchestra. (Courtesy of the Earl Pittman family.)

Pittman is seen here with his strings class at Douglass High School in the late 1950s. (Courtesy of the Earl Pittman family.)

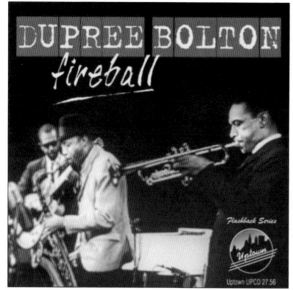

Dupree Bolton was born in Oklahoma City on March 3, 1929. At the age of five, his father, who had been Charlie Christian's early influence, encouraged Dupree to study violin, but he was determined to play the trumpet. At 15 he ran away from home to join the Jay McShann Band. He began playing with Charlie Parker, who introduced him to a life of drugs that caused him to spend most of his time in and out of prison. A bebop player, Dupree molded himself after Dizzy Gillespie, but he idolized Fats Navarro. After leaving prison in 1959, he became an amazing trumpeter. He used incarceration as an opportunity to hone his technique, practicing up to 14 hours per day. His album, *The Fox*, became a masterpiece. (At left, courtesy Black Liberated Arts Center, Inc.; at right, photograph reprinted with permission of Ted Gioia.)

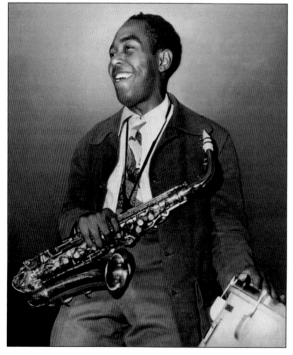

In 1962, Dupree Bolton joined musician Curtis Amy (pictured) and composed *Katanga*. Later he joined Harold Land for the highly praised *Fireball*, where he proved himself a talented soloist. In San Quentin, Bolton began playing with Frank Morgan, who received the Downbeat Critics Poll Award in 1991. Dupree Bolton died on June 5, 1993. (Courtesy Black Liberated Arts Center, Inc.)

Freddie Cudjoe, one of Evelyn Pittman's disciples, was born in Sapulpa, Oklahoma, and graduated from Langston University with a bachelor's degree in music. She earned a master's degree in music from Western Colorado University and a doctorate in education administration from Oklahoma University. Cudjoe sang with the Evelyn Pittman Choir and played parts in several of Pittman's productions, including the role of Coretta King in *Freedom Child*, performed at the John F. Kennedy Center for the Performing Arts in Washington, D.C., and Oklahoma's *Jim Noble*. Cudjoe appeared in local shows, including *For Colored Girls Who Consider Suicide When a Rainbow is Enuf*, which was produced by BLAC, Inc., and *Hello Dolly*, produced by Langston University. In the photograph at right, she is on the far right and pictured with Gary Zachary and Mattie "Mika" Wickfield from the cast of *Hello Dolly*. A poster from the show is seen below. (Both courtesy of Freddie Cudjoe.)

LANGSTON UNIVERSITY
DEPARTMENT OF COMMUNICATION

Presents

AMERICA'S ALL-TIME FAVORITE MUSICAL COMEDY

"Hello Dolly"

THE NEW DUST BOWL THEATRE

APRIL 14, 15, 20, 21, 22, 23, 24 - 8:00 p.m.

SPECIAL MATINEES APRIL 14, 15, 20, 21, 22, 23, - 12 NOON

NO ADMISSION CHARGE

For Ticket Reservations Write:
Department of Communication, Box 185, Langston University, Langston, Oklahoma 73050
OR Telephone - (405) 466-2281 ext. 284, 285, 286, 287

PLEASE reserve your seats well in advance of Performance

Reservations will be held until 15 minutes prior to Performance

BEN TIPTON "TALL MAN"
KBYE Radio, Oklahoma City, Oklahoma

Ben Tipton was known as the "The Tall Man," and everyone in Oklahoma City knew him because he was on local radio station KBYE. He played all of the good music, from blues to jazz. He was the radio voice for music during the 1960s and 1970s. From radio, he migrated into promotion and production. Lou Rawls had frequented Oklahoma City, singing in clubs, and he was tired of it. Tipton presented Rawls on the professional stage in Oklahoma City's Municipal Auditorium in the early 1970s, winning the gratitude of the singer. Tipton brought others to the venue, including the Supremes, Joe Simon, and James Brown (pictured below). Tipton's father, Loyd, was an excellent piano player who played with local bands during the 1950s and 1960s. (Both courtesy of the Ben Tipton family.)

Ben Tipton became friends with celebrities, but he remembered his roots. The Douglass High School graduate was born in Oklahoma City in 1934. He matriculated to Central State University and Oklahoma University. He often appeared with his celebrity friends when they performed at local events, including tributes, dances, and other events where he served as the master of ceremonies. Tipton started a communications trainee program in radio, where he taught others interested in a radio career. His career in communications spanned 30 years from Oklahoma City, to Detroit, to Chicago. He went from radio to television and came back to Oklahoma City to host and produce his own television show, *Black Revue*, at KOCO-TV. Oklahoma City paid a final tribute to Tipton on July 28, 1986, when his musical contributions to the city were honored. (Both courtesy of the Ben Tipton family.)

TRIBUTE TO A TITAN
BEN TIPTON
A MAN AND HIS MUSIC

FEATURING

Gospel	Jazz and Blues
Prospect Baptist Church Choir E. J. Perry Ensemble Rozie Turner - Solo Ebenezer Baptist Church Choir New Zion and Johnnie Hill Rodney Foster - Solo	BLT Band (Bottom Line Transaction) Main Event Band The Jimmy Wilson All-Stars Band

Sunday, July 27, 1986
4:00 pm - 8:00 pm

The Oklahoma Conference Center
(formerly The Centre)
5901 North May Avenue
Oklahoma City, Oklahoma

Admission $10.00

for ticket information
call 557-2174

Oklahoma City got its first black-owned radio station with KAEZ Radio in the late 1970s. Jimmy Miller, Jesse Robinson, and Raymond Harrison, the station owners, had an all-black staff of disc jockeys and newsmen. Chris Arnold, who began in radio at age 14 in Memphis, was a popular deejay who sold advertising at the station while studying at Oklahoma University in 1977. Arnold pumped new energy into the station after attending a radio convention in Atlanta, where he made national contacts for the struggling radio station. In 1979, he moved to KATT Radio for a year and then on to KTVY, an NBC affiliate. Upon graduating from the University of Oklahoma, Arnold headed to Texas to begin a sports broadcasting career in 1980 at K104-FM in Dallas. There he served as sports director, covering major events and serving as courtside reporter for the Dallas Mavericks. Arnold had his own show, *The Ticket*, and was awarded a regional Sports Emmy. He ventured into television with his own show, *The Beam*, which was seen in 46 cities around the world. (Courtesy of Chris Arnold.)

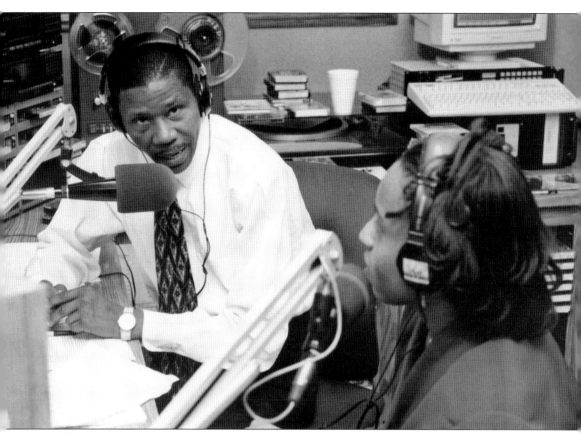

Fred Elkins Jr. started broadcasting in 1973 as a radio announcer and weekend newsman for KFJL Radio in Oklahoma City. Moving to Tulsa, he accepted a position as music director for KKUL Radio before moving on to KTFX Radio, where he signed on as host of the *Music Appreciation Hour*. Elkins joined the new radio station KAEZ as program director during the late 1970s, managing a nine-man staff of disc jockeys and a three-man news staff. Elkins served in that position until the station was sold in the mid-1980s. While working at KAEZ, Fred gained valuable radio experience that served him well at three other Oklahoma radio stations before coming back to Oklahoma City to join another black-owned radio station, KVSP Radio. The station, operated by the Perry Publishing Company, was owned by Russell Perry, an Oklahoma City businessman. Radio had moved from the 1940s through the 1950s with Clayborn White, a popular radio personality and well-known radio reporter, along with Abram Ross, who broadcasted from his home. (Courtesy of Fred Elkins Jr.)

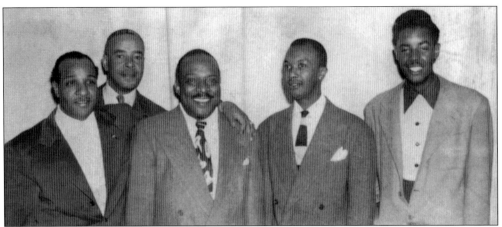

Things had changed drastically in Oklahoma City by the late 1950s. Television had made a dent in the radio market, and integration was slowly taking place, which was bringing a change to the lifestyles of blacks in Oklahoma City and was negatively impacting business on Second Street. People were buying goods and services elsewhere. The thriving business district was trying to hold on, but times were changing, and most of what had been were now fond memories lingering in the minds of blacks in northeast Oklahoma City. All of the swinging "cats" were gone, but Leslie Sheffield was still around. He was playing regularly, and his family was growing. Sheffield still had gigs, but they were not in the same places; he had to change with the times. He remembered those experiences when Count Basie would drop in for a few days and pay his respects. Pictured here is just such a moment. Count Basie (second from left) stands next to Sheffield (third from left). (Courtesy of Ellen Sheffield.)

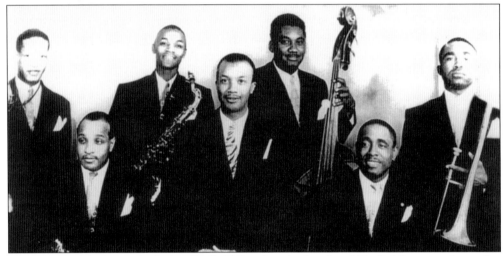

This photograph shows the Leslie Sheffield Band at the height of Sheffield's career, long after his friend Charlie Christian had departed the scene. Although there were some questions raised at home about the ownership of the tune "Flying Home," recorded by Benny Goodman with Charlie Christian, Sheffield maintained a close friendship with Christian. The word was it was Leslie's tune, and many, including Mary Lou Osborne, claimed to have heard the song played by the Leslie Sheffield Band in the mid-1930s in places as far away as Bismarck, North Dakota, years before Goodman and Hammond got their hands on it. It is a continuing debate within the Sheffield family. The Leslie Sheffield Band continued to play the tune, as did Goodman and Charlie Christian. (Courtesy of the Leslie Sheffield family.)

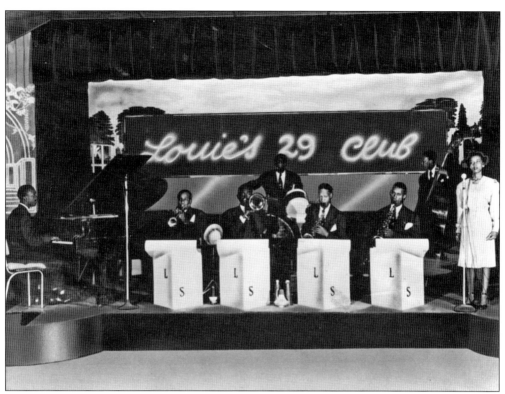

In the 1950s and 1960s, Sheffield and his musicians were playing mostly in clubs and for social club dances. In the photograph above, the Leslie Sheffield Band plays at Louie's 29 Club, a popular establishment located on Southwest Twenty-ninth Street near May Avenue. Louie's 29 Club was one of a few places that featured a complete show, from time to time, with music, dance, and some comedy. Leslie Sheffield is seen to the left on the piano. Sheffield and his men, like so many others during those times, dressed professionally, unlike generations that followed. Leslie Sheffield, seen at right smiling, died in Oklahoma City in 1979, leaving his wife, Eula, and three children, Leslie Jr., Debra, and Ellen, who became a well-known pianist and organist in Oklahoma City and Los Angeles. (Above, courtesy of the Oklahoma History Center; at right, the Sheffield family.)

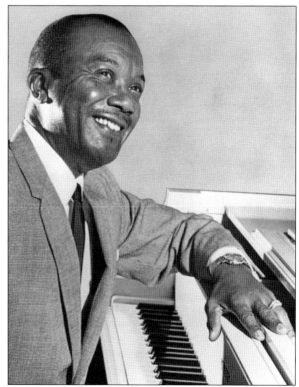

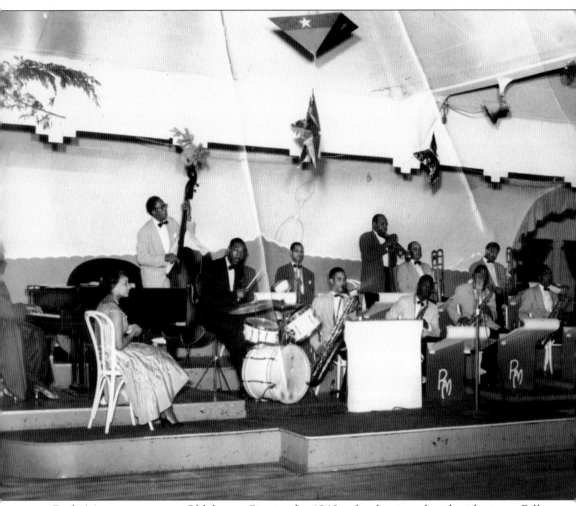

Rudy Morrison came to Oklahoma City in the 1940s after having played with singer Billy Eckstein. After getting familiar with Deep Deuce musicians and how the music scene operated in Oklahoma City, Morrison started his own band and called it the Rudy Morrison Band. Eugene Jones Jr. was one of the well-known musicians in town, and he was recruited by Morrison to play for him. His band became popular on the social club circuit, playing at the Trianon Ballroom and Blossom Heath, among others. In this photograph, taken at one of the club dances, the band members are Rudy Morrison (drums), Frankie Jordan (piano), Carl White (bass), Eugene Jones (baritone saxophone), Harold "Uncle Cy" Cannon (saxophone), Seawood Evans (a friend of Charlie Christian), Harlinza Bradshaw (saxophone), Roy Moore (trumpet), and Henry Butler (trombone). (Courtesy of Eugene Jones.)

Sonny Morrison (at right), a popular bandleader from the 1950s through the 1970s, and his band, the Soul Messengers, made their first recording under their new name, Messengers Incorporated, in the 1960s. The album *Soulful Proclamations* features Morrison as the vocalist, backed by Charles and Barbara Burton on guitar and vocals, Morris McCraven on alto and tenor sax, Maurice Love on organ and vocals, James "Bucky" Young on bass, and Maurice Howard on drums. The introduction was provided by Jimmy Miller. KFJL-FM praised the classical blues voice of Morrison. This rare album includes favorites like "Ain't No Mountain," "Eleanor Rigby," and "Rejoice." The photograph below was taken in 1969 at the Oklahoma City Sheraton Hotel. It shows the band in the background playing for the Les Mannequins, a modeling club popular in the 1960s and 1970s; Kathryn Roberts poses in the foreground. (Both courtesy of Morris McCraven and Black Liberated Arts Center, Inc.)

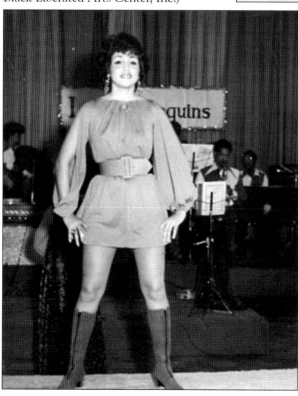

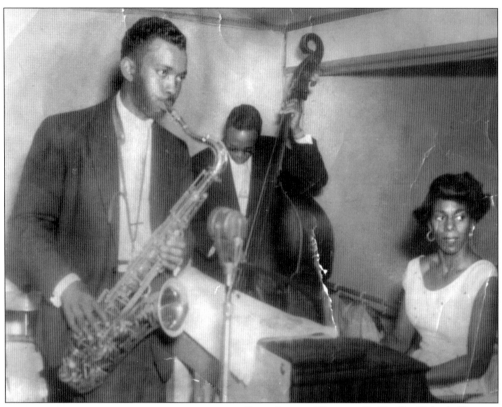

Saxophonist Clarence B. Griffin II (at left) was born to Myrtle and Clarence B. Griffin in Oklahoma City in 1929. Influenced by his father, a classical baritone who belonged to several of the city's local choral societies, Griffin took odd jobs making money for music lessons at the age of seven. Sneaking up to Slaughter's Hall, he listened to Charlie Christian and eventually played with legends Thad Jones, John Coltrane, and Gene Ammons. Influences included classical and gospel music, but Griffin loved jazz and adored pure improvisation. According to his daughter Crosby Griffin, "The thing that happened between the dots" mattered most to him. An eloquent gentleman, Griffin could take a standard that spoke of love lost or the enthusiasm of bebop and make his horn tell the story with his special riff or inflection that was his signature style. He formed his own band, which was popular for more than 20 years. He was photographed playing an engagement, seen above, with Frankie Jordan on piano and Carl White on bass. He worked for the post office for 35 years. (Above, courtesy of Eugene Jones; at left, Griffin family.)

Elmer Kemp came to Oklahoma City in the early 1950s and eventually owned three nightclubs. Kemp is pictured behind the bar in one of his clubs, Elmer's, located on Northwest Twenty-fifth and Walker Streets in Oklahoma City. Kemp became a pioneer in the nightclub-ownership business after integration. He owned one of the first clubs in northwest Oklahoma City, signaling the end of the heyday of Deep Deuce as the entertainment center for blacks in Oklahoma City. (Courtesy of Elmer Kemp.)

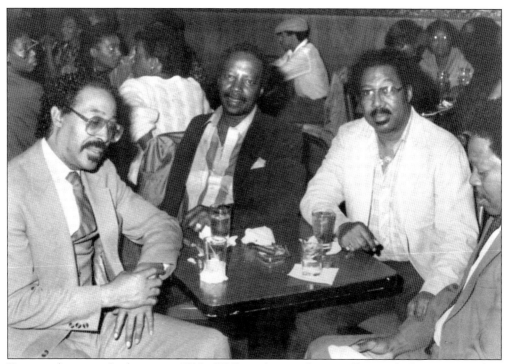

Kemp and veteran food manager Eddie Walker, along with singer Roosevelt Turner, opened up Bryant Center's Top Hat Club. Kemp's fondest memory was bringing singer Lou Rawls to perform at the Top Hat. From left to right, Carl Kemp (Elmer's brother), Eddie Walker (Elmer's former business partner), and Jetty Cox relax with Kemp over a drink at Elmer's Supper Club. (Courtesy of Elmer Kemp.)

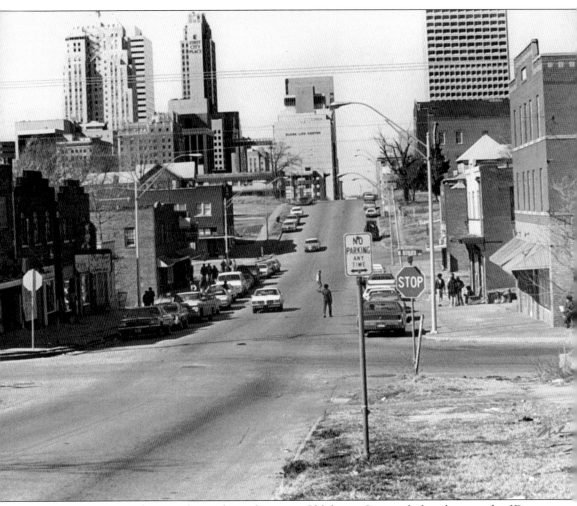

Maurice Miles, a photographer and visual artist in Oklahoma City, took this photograph of Deep Deuce in the 1950s. Miles captures Second Street after the Blue Devils, Charlie Christian, and Jimmy Rushing left Oklahoma City. Some of the buildings razed before this photograph was taken include the Aldridge Theater, the Canton Hotel, and Ruby's Grill. At the time, the three-story Slaughter Building that housed Randolph Drug Store on the first floor and Slaughter's Hall on the third floor was still standing, as seen in the right corner of the picture. Calvary Baptist Church overlooks downtown Oklahoma City at the top of the hill on the same side of the street. The Black Dispatch Office (directly across from the Slaughter Building) and the Littlepage Hotel (last building before vacant lots) are seen on the opposite side of the street. (Courtesy of Black Liberated Arts Center, Inc.)

Trumpeter James Artellia Nelson, born in Cameron, Texas, on May 6, 1922, moved to Oklahoma City, where he studied under Zelia N. Page Breaux and was a member of Breaux's Douglass High School band. After graduation, this Breaux disciple joined the military, where he honed his musical skills as a member with the U.S. Navy Band. Upon receiving an honorable discharge, Nelson returned to Oklahoma City and played with Earl Pittman's All Stars, Johnny Herrod and the House Shakers, and many other local bands. Nelson is shown in the photograph at right about 10 years before his August 2007 death. In the April 1988 photograph below, Nelson appears at the Charlie Christian Jazz Festival with vocalist Eva Narcissus Boyd, known as "Little Eva," a well-known singer in the 1980s. (At right, courtesy Provo family; below, Black Liberated Arts Center, Inc.)

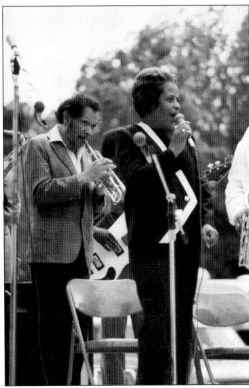

Integration was being discussed in the early 1950s, and Zelia Breaux would retire from teaching and die in 1956. Second Street was not what it had been, but Douglass High School was still turning out good musicians, and the impact of change had not taken its full toll yet. Douglass students were still taking all of the music courses that Breaux had put in place, and some remaining Breaux disciples were graduating. A few looked beyond Deep Deuce and Oklahoma City. The Spears brothers, Louie B. (below) and Maurice (left), who grew up around the Second Street area, finished their education, lingered for a moment, and then headed for California, where they earned a reputation of excellence as musicians and educators. Both played music and taught; however, Maurice Spears became a bandleader and was a composer for more than 40 years. (Both courtesy of Black Liberated Arts Center, Inc.)

Marion Harkey was influenced by G. L. Buford and E. W. Perry, band instructors at Douglass High School. Harkey pursued his musical interests by playing with Sam Cook in Memphis, and he later returned to Oklahoma City to form his own blues band, Time Warp. Shown in the photograph above, Harkey picks a guitar with his teeth at the Hole in the Wall Club in 1993. During the mid-1950s, the Dukes, a rock-'n'-roll singing group made up of close friends from Douglass High School, moved to Las Vegas. The original group, shown in at right, included (from left to right) Billy Armstead (tenor, lead vocals), Richard Williams (bass), Everett Edwards (tenor, lead vocals), Willie Moon (tenor, lead vocals), and Don Nero (tenor, lead vocals); the late Elmer Lee Husdon (tenor) is not pictured. After playing nightclubs and recording, their stars soon fizzled. (Above, courtesy of Marion Harkey; at right, Sharon Dean.)

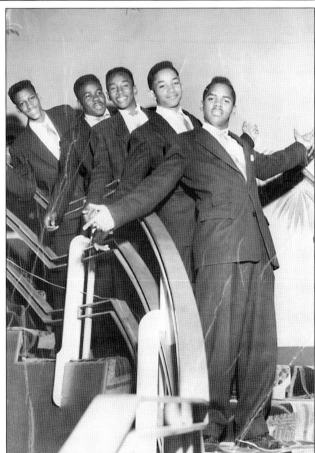

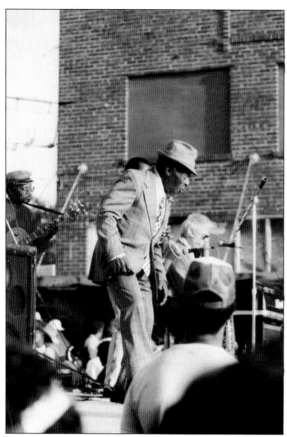

By the early 1980s, Deep 2 lay in ruins as owners died and others sold out when they could. Integration had taken effect, and blacks no longer went to buy goods and services on Deep Deuce. Some grumbled about the plight of the area but did nothing. James "Doughbelly" Brooks still lived there amid the clutter in a small building that seemed abandoned. A friend of the musicians from long ago, including Charlie Christian, Seawood Evans, Jimmy Rushing, and others, Doughbelly was a former dancer and minstrel show performer. He declared he would never leave Second Street. This street icon, who sold newspapers to anybody who happened to drive by, was consistently interviewed by reporters. Doughbelly is seen in the photograph at left. The image below shows the south side of Deep Deuce. (Both courtesy of Black Liberated Arts Center, Inc.)

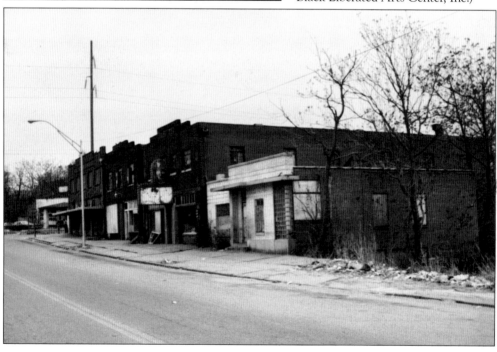

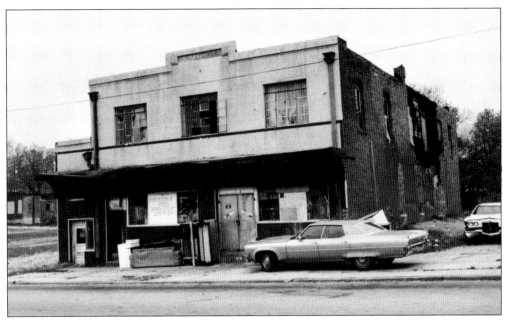

As time passed, buildings were pillaged by anyone who wanted to do such a thing, and it was said that there were looters who went in some places looking for valuable artifacts that may have been mistaken for junk. In the above photograph, taken in 1988, one of the remaining buildings on Deep Deuce has broken windows and shows signs of vandalism and neglect. Farther down the street, at the Littlepage Hotel, home of the Blue Devils when they were in town, one business seems to be trying to hold on, waiting like Doughbelly for the Deuce to rise again. The hotel is seen on the right in the photograph below, which was also taken in 1988. (Both courtesy of Black Liberated Arts Center, Inc.)

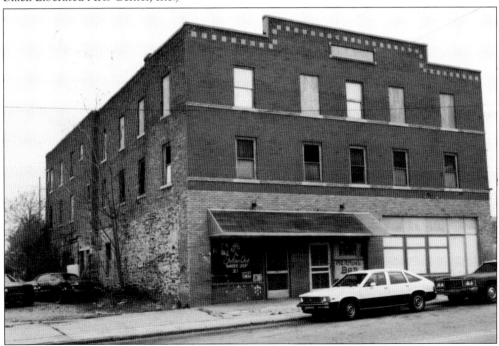

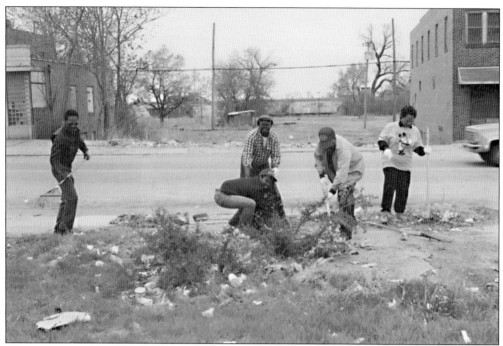

Change was coming; signs of it began to appear in the mid-1980s. The City of Oklahoma City required that property owners in the area board up vacant buildings. Urban Renewal had purchased some properties and began to sell them. It was 1985 when the Black Liberated Arts Center, Inc. decided to create a street festival in honor of Charlie Christian on Second Street. The festival committee decided to ask the community to join in a cleanup of the Deuce. Photographs from 1988 show volunteers cleaning the street, getting ready for the festival. (Both courtesy of Black Liberated Arts Center, Inc.)

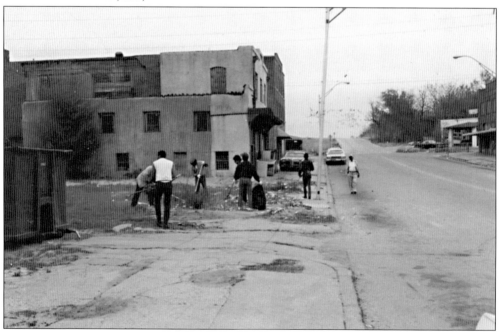

Four

MUSICAL FAMILIES

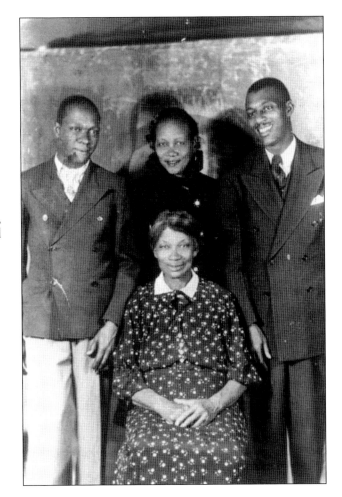

Charles Henry Christian was born into a musical family that included his blind father, Clarence, a guitarist; his mother, Willie Mae, a pianist who played several other instruments; his maternal grandmother, Ella George, a pianist; his brother Clarence Jr., who played string instruments; and his brother Edward, a pianist who played several other instruments. Shown here are Mama Ella (seated in front) and from left to right (standing) Clarence Jr., Willie Mae, and Edward. The photograph was probably made after Clarence Christian had died and Charlie had left to join the Benny Goodman Band. (Courtesy of Black Liberated Arts Center, Inc.)

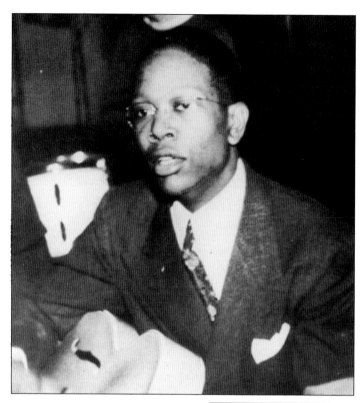

Charlie Christian, the youngest son, is seen in a photograph taken in early 1940 when he played with the Benny Goodman Band. He was the father of one daughter, Billie Jean, whose mother, Margretta Christian, migrated to Oklahoma City as a child from Texas. Charlie and Margretta met as teenagers living in the Deep Deuce area, and friendship turned to romance. (Courtesy of Black Liberated Arts Center, Inc.)

Billie Jean Christian was born on December 23, 1932, in Oklahoma City. She married but had no children. When asked by Anita Arnold, executive director of BLAC, Inc., why she never had children, particularly since she was the last of the Christian family, Billie laughed and said, "You should have told me that 40 years ago, now it is too late." She died on July 19, 2004, marking the end of a musical family legacy. She is shown here posing with a smile. The Black Liberated Arts Center, Inc. donated headstones for the graves of Charlie Christian and his daughter. (Courtesy of Margretta Christian Downey.)

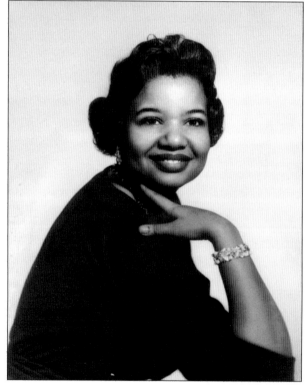

Many families in Oklahoma City had at least two members who were known for their music. One such musician family included Jimmy Rushing, who became the world's greatest blues shouter, and his father, trumpeter Andrew Rushing. Another was the Earl Pittman family. Evelyn Pittman's family, not related to Earl's family, had several members who performed music. Evelyn traveled the world with her choirs, educating people about great accomplishments of blacks in the United States through music. In doing so, she became an example of great accomplishment because she composed, directed, produced, and played out music about others. She took her choirs to Norway, Denmark, Sweden, England, Scotland, Italy, Liberia, and Ghana in the 1970s. Evelyn Pittman's Sextet included four members of her family. In this photograph, Evelyn stands at left with a guitar, her sister Blanch is third from left, her brother Isaac is on the end, and Johnnie Mae (Ike Kimbro's wife) sits at piano. When she died, Evelyn had more than 200 awards of recognition for her work. This photograph was taken in 1953 at Isaac Kimbro's home. (Courtesy of the Isaac Kimbro family.)

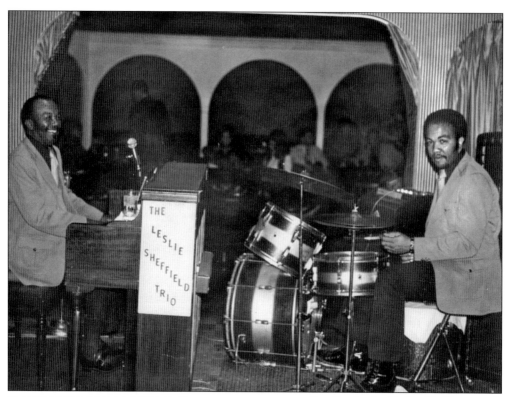

Bandleader Leslie Sheffield's musical family included Leslie Sheffield Jr.; daughter Ellen, a pianist and organist; and granddaughter "Muffy" Charles. Father and son made their reputations in Oklahoma City. Leslie Sr. passed his legacy on to his family. He had played with great musicians like Count Basie, Charlie Christian, and Jimmy Rushing. In the early 1930s, after forming his own band, Leslie Sr. helped shape the music of Second Street. The composer/conductor taught Ellen and Leslie Jr. the music business by taking them with him on gigs to absorb and experience the music. Above, Leslie Sr. plays piano while Leslie Jr. plays drums as the Leslie Sheffield Trio provides entertainment for the audience at a local club. Donetta "Muffy" Charles, a Los Angeles studio musician who kicked off a career in television and film, is shown at left. (Both courtesy of Ellen Sheffield.)

Earl Pittman and his son Andrew pose for the camera in the photograph at right. Earl was a quiet man who got things done. In 1991, he worked hard getting Zelia Page Breaux inducted into the Oklahoma Bandmaster Hall of Fame as an inspiration to future musicians. He was a traveling strings teacher in the mid-1950s with the Oklahoma City Public Schools and was inducted into the Oklahoma String Teachers Hall of Fame for his hard work. Earl taught Andrew guitar at home and included him in his gigs. The photograph below was taken at the 1988 Charlie Christian Festival. It shows Earl holding his beloved saxophone as he watches Andrew, seated with the guitar, swing down on Deep Deuce with Earl Pittman's All Stars Band. (At right, courtesy of the Pittman family; below, Black Liberated Arts Center, Inc.)

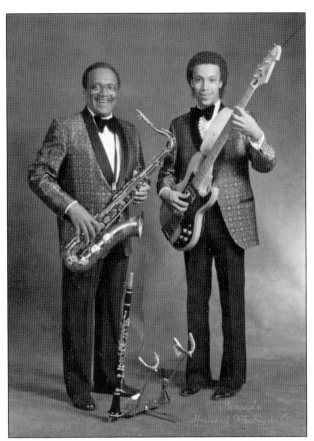

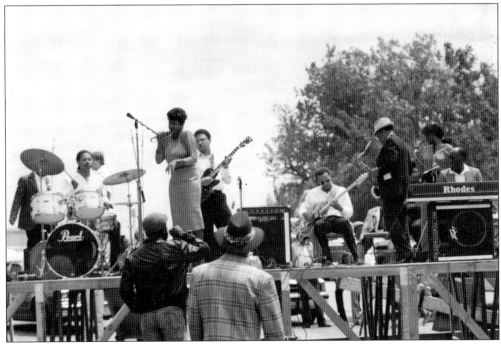

The Burtons started their musical career as a family when son Charles III "Tre' " was only three years old. Guitarist Charles Burton is pictured with his wife, Barbara, and Charles III. (Courtesy of the Burton family.)

Like his parents, at an early age it was recognized that Tre' was a talented drummer who took to the stage naturally. After performing with his parents, Barbara and Charles, in the Burton Band for a number of years, Tre' started his own, the Tre' Burton Band. At the same time, he continued to perform with his parents. The family now owns Diamond Recording Studio, where they are creating a musical legacy. (Courtesy of George Barnes.)

This award-winning family is worthy of the Charlie Christian Jazz Music Awards bestowed on them by Black Liberated Arts Center, Inc., at BLAC, Inc.'s annual recognition dinner that honors legends of the past. Louie B. Spears (left) is shown with brother Maurice Spears at the Petroleum Club in 2007 with their awards. The brothers, who live in Los Angeles, have notable accomplishments. Louie B., a bassist, recorded and performed with the likes of Hank Crawford, David "Fathead" Newman, Kenny Burrell, Donald Byrd, James Moody, and many others. He accompanied legends Lou Rawls, Nancy Wilson, Diana Ross, Pearl Bailey, Roberta Flack, Etta James, Abbey Lincoln, and Sammy Davis Jr. Maurice is a musician's musician. Internationally known as a music copyist par excellence, Maurice's client list includes Diana Krall, Lena Horn, and Peggy Lee. He and his brother are principals in the group Bonsoir, which features an all-star cast. Maurice has played and recorded with Herb Alpert; Hugh Masekela; Ray Charles; Con Funk Shun; Randy Crawford; Earth, Wind, and Fire; Quincy Jones; and Horace Silver. (Courtesy of Black Liberated Arts Center, Inc.)

George Wesley Sr.'s (above, left) music experiences include piano, trumpet, and vocals. He was a band member at Arkansas AM&N College and sang in the choir as lead soloist. Jessie Wesley (below, left) played piano at a young age and studied at Grambling State University, where she majored in piano and voice. Following graduate studies at Ohio State University, she joined the music staff at Langston University and later at the Oklahoma City Public Schools. She and George met and married in Oklahoma City. Son George Jr. (above, right), at the age of five, instructed his parents to sit down while he put on a recording of "The Greatest Love of All" and sang word-for-word with Whitney Houston. His youthful career includes singing the national anthem regularly at Oklahoma City Calvary basketball games and at openings of the NBA All-Star Game, the Republican National Convention, and the Boston Pops Fourth of July telecast. He was a runner-up on *Star Search*, and he sang for Pres. George H. W. Bush as a teenager. (All courtesy of George Wesley.)

Native Oklahomans, the Funches family is well known in the field of music. Georgetta Funches (at right), better known as "GiGi," has a vocal range from alto to first soprano. She began singing at the age of 19 and performed with Frank Sinatra, Diana Ross, Pearl Bailey, and the Four Tops. She plays violin, flute, and piccolo. She has appeared at the Las Vegas Hilton, Jilly's in Palm Springs, California, and internationally at Whiskey A-Go-Go in Tokyo, Japan, and at Club 58 in Geneva, Switzerland. Larry "Fantastik" Funches (below) started playing drums at age 12 and played professionally at 15. He performed with the Uptown Syndicate Band and opened for the GAP Band, Bobby "Blue" Bland, Midnight Star, and Natalie Cole. He was a session drummer for Rose Royce, and through his record company, 2 Rugged Records, he has launched the careers of other artists. (Both courtesy of Rosetta Funches.)

Two of the seven Walker children who studied music at Douglass High School pursued music careers. During the 1980s, master drummer Hugh Walker (above) accompanied Mary Lou Williams, Sonny Stitt, Buck Hill, and Hank Crawford, appearing in clubs around the world that included Sweet Basil in New York City, Au Dreher in Paris, Blues Alley in Washington, D.C., and Ronnie Scotts in London while working with Shirley Horn, Kenny Baron, "Fathead" Newman, Curtis Fuller, and James Moody. Walker worked extensively with Joe Williams, John Patton, Betty Carter, and Art Farmer. His brother Glen Walker, a master trombonist, left Oklahoma City to tour with Bobby "Blue" Bland, living briefly in New York City, Washington, D.C., and Los Angeles. Upon returning to Oklahoma City in the 1990s, he formed his own group, the Vintage Jazz Quartette, but he played with others, including Jimmy Wilson and the All Stars, and Gentlemen of Jazz. Below, Glen plays with Bottom Line Transaction. (Both courtesy of Joyce Dunlap.)

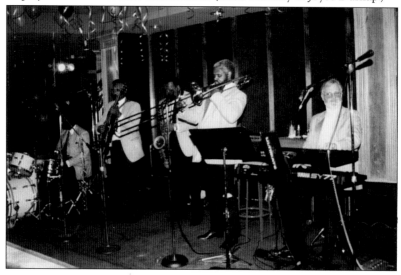

Five

DANCING THE PLANKS
OFF THE FLOOR

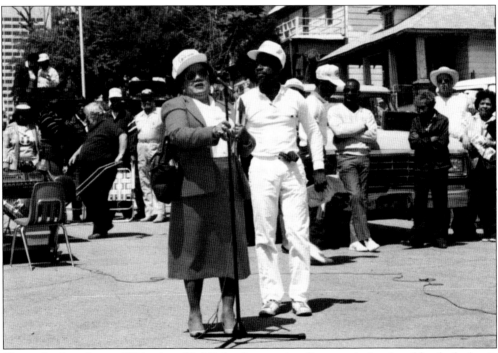

She said it first. It was 1994, when BLAC, Inc.'s executive director, Anita Arnold, asked what it was like at Slaughter's Hall. Oklahoma state representative Freddie Williams (left) laughed and said, "Girl, we liked to have danced the planks off the floor!" This was confirmed 15 years later by Harold Edwards. He said, "Slaughter's Hall was on the third floor of the Slaughter Building, but you could be down on the second floor, and you could feel and hear the planks jumping up and down when the band swung that tune!" Shown here in 1988, Freddie Williams stands with Greg Powell (right), festival cochair, on Deep Deuce getting ready for the biggest block party in Oklahoma City, the Charlie Christian Festival. (Courtesy of Black Liberated Arts Center, Inc.)

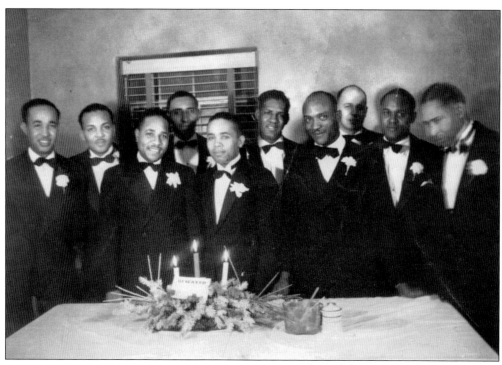

One of the most popular social clubs during the heyday of jazz was the all-male Grail Club, founded in 1932 by individuals who worked in Oklahoma City hotels, restaurants, and bars. These clubs gave fancy annual balls and parties from the 1930s through the 1970s and were invitation only. Great bands in great places with great people were the necessary ingredients for success and to become the talk of the town with mentions in Jimmy Stewart's column in the *Black Dispatch*. The Grail Club members that can be identified above, from left to right, are (back row) unidentified, Jimmy Green, unidentified, Isaiah Booker, Eugene Jones Sr., and Leon James (far right). A Grail Club invitation is shown at left. (Above, courtesy of Lilly Mae Booker; at left, Black Liberated Arts Center, Inc.)

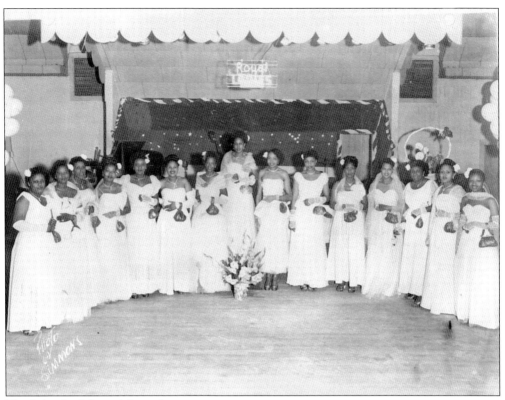

The ladies had their clubs and parties as well. Women spent months planning the intricate details of an event tied to a club. Meetings were held frequently to make sure everything had been well thought out. No club dance would be complete without a group picture taken of the event. The club photograph, taken in the early 1950s, shows the ladies with coordinated shoes, necklaces, purses, corsages in their hair, and gowns that are the same color; most of the women are wearing organza stoles around their shoulders or neck. Kathryn Brewer belonged to the Royal Ladies Club and to one or two clubs that were made up mostly of family members. She strikes a pose at right with her husband, Adolphus, at another party, where dancing is sure to be the highlight of the evening. (Both courtesy of Kathryn Brewer.)

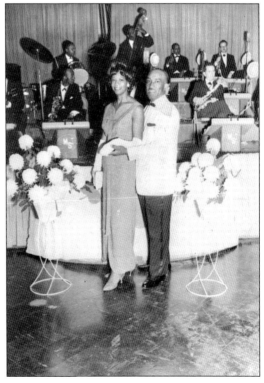

The Mystic 26 Club, founded around 1932, was mostly a couples club that put on an annual party at various ballrooms in Oklahoma City. This image was taken by well-known photographer Don Simmons of Simmons Studio in Oklahoma City, which was located at 918 Northeast Fourth Street. Seated on the sofa are, from left to right, (seated) Lonzetta Richardson, Jean Richardson, Augusta Perry, and two unidentified ladies; (standing) unidentified, Edward Richardson (husband of Lonzetta), Isaiah Booker, two unidentified members, Lillian Todd, Lilly Mae Booker, Dimple Dawson, Melvin Todd, and John A. Townsend. The photograph was taken in the home of Mr. and Mrs. Booker in the late 1950s or 1960s. (Courtesy of Lilly Mae Booker.)

The Swanky Club was one of the smaller social clubs whose membership consisted of friends. There were two sisters in the club, Alma Winrow and Juanita Davis. The photograph was taken in the early 1950s at the Blossom Heath Club, located on West Highway 66, which featured two ballrooms. This club's members always coordinated their outfits before making their appearance. Pictured from left to right are Katherine White, Alma Winrow, Mildred Crawford, Cleo Lewis, Billie Paulden, Opal Jefferson, Faye Forman, and Juanita Davis. Hard work went into preparing for the dance. Members made their lists of friends they were inviting and made comparisons at the frequent club meetings to insure perfection. The club meetings always had food prepared by the hostess for the members. In addition to the meetings, members spoke on the telephone daily to check on the progress of tasks to be performed to make sure there were no unforeseen problems. (Courtesy of Juanita Davis.)

COCKTAILS

Joe's Skyline Club

Music By
Charles Young
and His Orchestra

Oklahoma City

● TWO FLOOR SHOWS NIGHTLY ●

The image above is the front of a photograph cover that early photographers gave to guests at clubs and social club balls if the customer paid a photographer to take a picture of them at the event. This cover promotes the place instead of the photographer. Joe's Skyline Club was a popular club that couples dropped by to have a cocktail and dance; it offered two floor shows nightly. Trumpeter Charles Young and his orchestra provided the musical entertainment. The photograph of guests at the club was taken during the late 1930s. Shown below at the club are, from left to right, Willie Ray Smith Jr., Ellsworth Dinwiddie, Irene Dinwiddie, and Jack Kirk, who appear to be watching the action on the dance floor of one of the floor shows. (Both courtesy of Black Liberated Arts Center, Inc., donated by Irene Dinwiddie.)

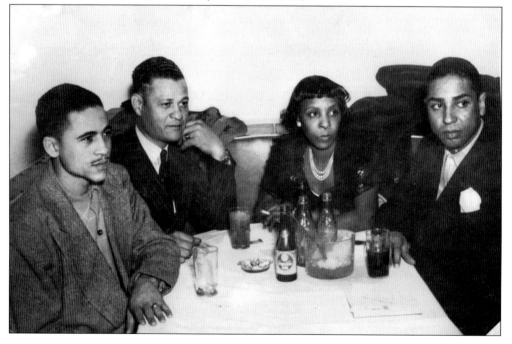

These photographs show elaborate invitations to dances by social clubs. The invitation from the all-ladies social club, Top Hatters, whose club colors were green and white, is multilayered. The photograph above shows how a fancy white cord with a tassel held several pages of the invitation together. The outside of the invitation was made of high-gloss black cardboard. The inside panel below announces the date, time, and place of the event. Other panels announce the band, Merry Makers; the club colors and motto; a list of officers, members, and honorary members; and finally a dance list with 10 numbered lines so that guests could record whom they partnered with for each dance. The final panel bids the guests, "Good Night," signifying the end of a perfect dance. (Both courtesy of Black Liberated Arts Center, Inc.)

These invitations to dances given by social clubs represent the diverse ways that information about the clubs and their events were presented. During the 1930s, multilayered invitations seemed to be popular. The Laff a Lott Club used a simpler invitation to communicate information. Other details included the date, time, and place. Most invitations at this time showed Slaughter's Hall as the place, but a few used the Ritz Club as a venue. Names of the members and what to wear were given. (Courtesy of Black Liberated Arts Center, Inc.)

Some invitations, such as the Silver Slippers and Walking Canes, gave the members' names, as well as the date, time, and place of the event. It was a ladies and gentlemen's club. (Courtesy of Black Liberated Arts Center, Inc.)

Six

THE STARS AT NIGHT

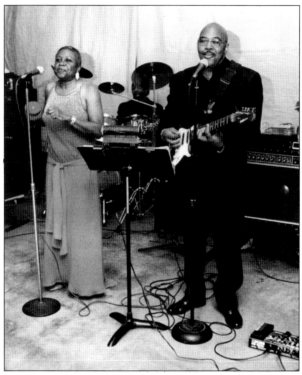

Charles Burton played professionally beginning at the age of 15. Extremely versatile with a thorough knowledge of his instrument, Burton's wide vocal range set him apart as a gifted singer, writer, arranger, and recording engineer. He toured with Tom Jones, Count Basie, Gladys Knight and the Pips, and appeared in all the major cities in the United States and Canada. Barbara Gillespie Burton started performing at the age of 12, when she appeared in a performing-arts program at Benedictine Heights College in Tulsa, Oklahoma. A special part was written for her to sing in *As You Like It*, a Shakespearean play. Her musical influences include her aunt Daletessa Gissespie, who played organ and sang, Dakota Station, Nancy Wilson, Sarah Vaughn, Gladys Knight, and Aretha Franklin. Barbara performed as a front act for Nancy Wilson and "An Evening with Vic Damone." Barbara and Charles have recorded as Soul Messengers, Burton, Inc., and the Burton Band. They performed at the 15th annual Grammy Awards as new artists and were inducted into the Oklahoma Jazz Hall of Fame in 2001. (Courtesy of Charles Burton.)

Some "cats" had been at the game for a while, and Morris McCraven is one that had been there and done that. The saxophonist migrated to Oklahoma City from Memphis in 1959 to attend Langston University on a full scholarship. After graduating in 1963, Morris hit the ground running in music, playing with Charles and Barbara Burton, Preacher Smith, George Moreland, and Chester Thompson. After that, he played with Jackie Wilson, Lou Rawls, Roy Hamilton, Little Willie John, Hank Marr, Sonny Stitt, Jay McShann, and many more. (Courtesy of Morris McCraven.)

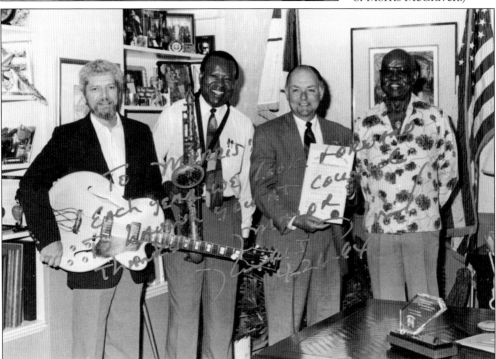

A master of circular breathing, Morris McCraven amazed audiences with his ability to seemingly play endlessly without taking a breath. In 1985, the Morris McCraven Trio established a tradition of opening the annual Charlie Christian International Music Festival. Pictured from left to right are Bob Nelson, Morris, Mayor Ron Norick, and Earl Fletcher. (Courtesy of Morris McCraven.)

Walter F. "Doctor" Taylor III began playing drums at age 11 and was playing in clubs by age 13. He played with more than 50 bands. Beginning in the 1970s, Taylor played with the some of the best music talent in Oklahoma City, and he stands out as a creative force in music. A master drummer, bandleader, producer, and vocalist, the "Doctor" made his rounds, playing with Little Johnny Taylor, Uptown Syndicate, Juanita Ellington (relative of Duke Ellington), and Rufus Thomas, to name a few. (Courtesy of Walter Taylor.)

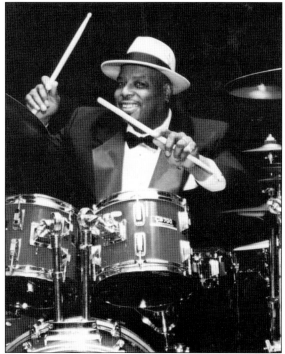

As a member of the sensational After Five trio, along with Maurice Johnson (left) and David Carter (center), Taylor (right) traveled extensively and in 1990 recorded the wildly successful album *Expressions*. It was an original collection of songs that included rhythmic romantic ballads, jazz fusion, and funky get-down rhythm and blues. (Courtesy of Walter Taylor.)

One of the most exciting groups to come out of Oklahoma City was Uptown Syndicate. The group started in the 1970s in a new genre called soul and funk, recording its first single, "Uptown/ You're a Woman," gaining the attention of promoters outside of Oklahoma. Uptown Syndicate moved from a local rage to the Chitlin Circuit that was mostly centered in the South. In 1977, the group made its second 45, "Bloated/Just Be Yourself." The group traveled to the Carolinas, Florida, Alabama, Mississippi, Georgia, Texas, Kansas, Arizona, and New Mexico. Late nights and long trips were part of the calling. This 1977 promotional photograph shows, from top to bottom, Walter Taylor III, Bo Walker, Karl Wilburn, Eric Doss, Virgil French, Charles Barnett, and Brenda Gunn; Temple McKinny stands on the left, and Steve Gunn is on the right. (Courtesy of Walter Taylor.)

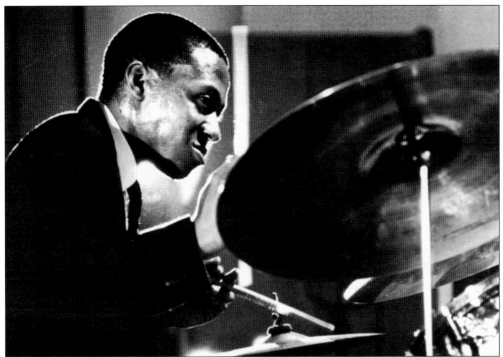

Delmar Thomas Burge Sr. lists W. E. Perry, Earl Pittman, and G. L. Buford, three 1950s band instructors, as his musical influences. Captain of the Douglass High School drum section by the age of 15, Burge had played at all of the clubs on the east side. In the 1960s, he played with Jimmy Reed and Merle Lindsay. In 1964, the military sent him to Tokyo, where he became bandleader with the House Rockers, as seen in the photograph below. They toured major cities in Asia and recorded three albums. In 1969, when Burge brought artists Sam Moore and Dave Prater (known as "Sam and Dave") of Stax Records to Tokyo, he was invited to join them in New York City. While there, he played with King Floyd at the Apollo Theater, Jerry Butler, Wilson Pickett, Major Lance, David Ruffin, Solomon Burke, Thad Jones, and others. (Both courtesy of Delmar Burge.)

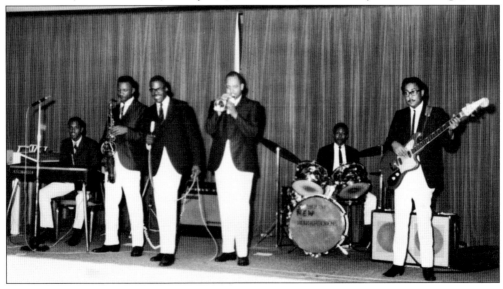

Chester Thompson, a 1972 Douglass High School graduate, began playing music at the age of five. After playing with local musicians, at age 19, he headed for San Francisco upon invitation to join the Rudy Johnson Trio. The keyboardist, composer, producer, and lead musician left the trio shortly thereafter to become the power behind the R & B funk group Tower of Power. Thompson spent 10 years with Tower of Power, writing, recording, and playing before launching a long career in 1983 with Grammy Award–winning guitarist Carlos Santana. Thompson traveled all over the world, sharing the spotlight with Wayne Shorter; Earth, Wind and Fire; the Temptations; and others. For the 1987 album *Blues for Salvador* and the 1990 release *Spirits Dancing in the Flesh*, he cowrote several tunes with Santana. He is seen here at his Yamaha in Santa Barbara, California. (Both courtesy of Chester Thompson.)

Harold Jones, a bandleader, producer, and musician, organized Bottom Line Transaction (BLT) in August 1981 after playing and traveling internationally with the 3rd Avenue Blues Band. Because of this experience, he was able to break down racial barriers by playing both sides of town with BLT. Members of the band were Harold Jones (drums), Edgar Scott (guitar and vocal), Morris McCraven (alto and tenor saxophone), Larry Judd Pierce (keyboards), and Johann Kimbro (bass). They recorded two albums, in 1983 and 1986, respectively. (Courtesy of Harold Jones.)

Harold Jones became a key advocate in promoting jazz in Oklahoma City through his jazz productions. Two of his most important works include the NTU's "Jazzin," an annual indoor jazz event held in the fall, and he was one of the original founding producers and promoters of the annual Charlie Christian International Music Festival. (Courtesy of Black Liberated Arts Center, Inc.)

Talented musicians since the 1920s left Deuce Deep and the city chasing their dreams, while others stuck around. Drummer George Moreland (above) was one who left. In the 1950s, at age seven, his interest in music was sparked. By age 13, he was doing gigs in clubs. From 1968 to 1971, he played with Gladys Knight, Marvin Gaye, and the Temptations. Then he played for five years with the Isley Brothers. Finally in a career that lasted more than 30 years, Moreland played with Millie Jackson. Born on May 10, 1949, Curtis Ragsdale (below, center) learned piano at age five and guitar at 10. After his military discharge, he played guitar with his mentor, Earl Pittman and his All Stars Band, for 10 years. He worked with blues artists Miss Blues and Miss Peggy, and played in clubs and at jazz and blues festivals. (Above, courtesy of George Moreland; below, Curtis Ragsdale.)

Master guitarist Johann Kimbro, known as Shortt Dogg, was the bandleader and chief executive officer of Shortt Dogg Entertainment. Kimbro learned piano from his mother, pianist Johnnie Mae Kimbro, at age five and caught music fever. Two years after graduating from Oklahoma City University, Capitol Records lured him away for a two-year gig as a studio musician in Los Angeles. There he played with Tyrone Davis, Al Green, and Smokey Robinson, to name a few. (Courtesy of Johann Kimbro.)

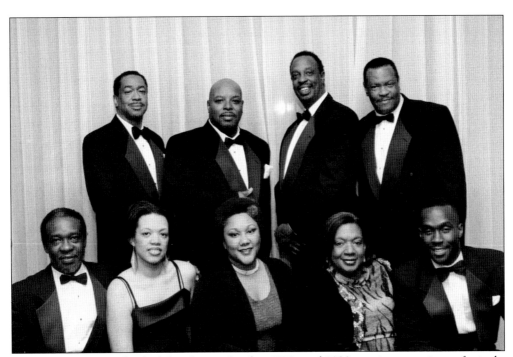

Johann Kimbo's popular funk band specialized in 1970s and 1980s music, appearing at festivals, casinos, and clubs. Pictured from left to right are (first row) Phillip Smith (saxophone), Ckai Dawson (lead background vocalist), Nikki Nicole (vocalist), Shawn Dawson (keyboards, vocalist, and composer), and Spencer Browne (band poet); (second row) Rocky Armstrong (guitarist), Walter Taylor (drums), Johann Kimbro, and Reginald Thomas (pianist). (Courtesy of Johann Kimbro.)

The stars at night shine big and bright from Oklahoma City to Texas, and these two down-home funk/rhythm-and-blues bands, formed in the late 1970s in Oklahoma City, could heat it up or settle into a mellow jazz tune, providing total satisfaction. Glass Pyramid is shown above with Delmar Garrett (front center) and vocalist Georgetta Funches (far right) among other members. The Jokers Y-ild band, founded by nine musicians who shared ideas and money, moved to Texas in the late 1980s after rave reviews in Oklahoma. They are seen in the photograph below. Candy Williams (lead vocalist) added a soft feminine voice that made the group stand out. The band members, from left to right, are (seated) David Carr Jr., Candy, and Charles Thompson; (standing) Sam Hankins, Rodney Johnson, Willie Threat, Ray Shaw, Gerald Johnson, and Walter Taylor III. (Above, courtesy of Black Liberated Arts Center, Inc.; below, Walter Taylor.)

Buster Floyd Green Jr. (right) was born on March 4, 1944, in Louisville, Oklahoma. He graduated from Douglass High School in 1962 and later received a bachelor's degree in music. Green specialized in the saxophone and flute and loved composing music. He played with Charles and Barbara Burton and with Preacher Smith prior to his move to California to begin a music career as sideman with Sam Cook and Ike and Tina Turner. Aaron Harvey King (below) started playing guitar at the age of 6 and began playing professionally at age 13 with Gary and B. B. Coleman and the Charm in Grant, Oklahoma. He played with Freddie King and Little Johnny Taylor, and after a military stint he joined other blues bands and worked with various performers, including Chick Wilson, Co Co Taylor, Joe Blue, and Mississippi Pete. (At right, courtesy of Walter Taylor; below, Aaron Harvey King.)

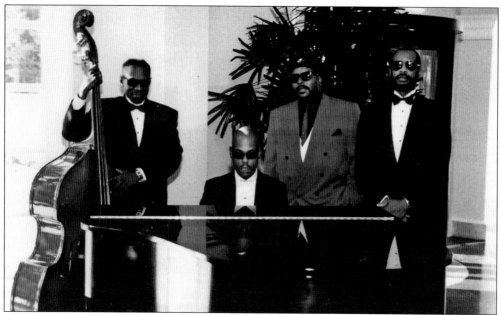

Seen above, bassist Phillip Mitchell (left) joined forces with saxophonist Gary Clardy (far right); John Harris (seated), former pianist for Miles Davis, Cheryl Lynn, and Tower of Power; and Walter Taylor (second from the right) on drums to form Mitch's Brew in the early 1990s. Dedicated to preserving jazz history, the quartet performed more than 300 shows that were described as energetic with a wide range of musical composition, including Ellington, Gershwin, and Miles, in and around Oklahoma. The Time Warp Band (below), formed in 1988 by Marion Harkey to preserve the blues legacy in Oklahoma, belts out tunes in the tradition of Z. Z. Hill, B. B. King, Ray Charles, Little Milton, Bobby "Blue" Bland, and more. Pictured from left to right are (standing) Robert Harris, Ron Harding, James Russell, August Mothershed (vocalist), Derrick Woolfolk (drummer), and Roy Gene Smith; (seated) Marion Harkey (bandleader) and Nat Eckford (vocalist). Ron Harding was killed in the Oklahoma City bombing on April 19, 1995. (Above, courtesy of Phil Mitchell; below, Marion Harkey.)

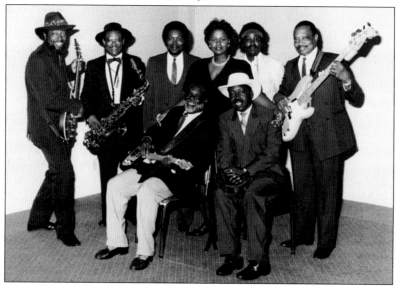

Seven

WE'VE GOT CHOIRS

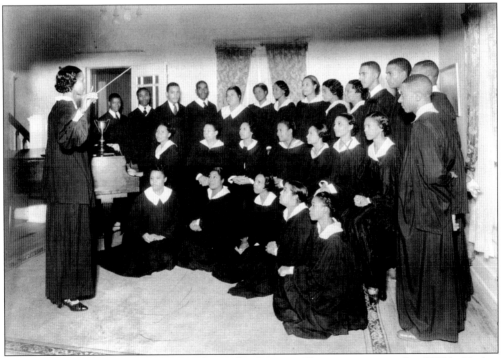

The most famous choir in Oklahoma, the Evelyn Pittman Choir, was organized in 1938 by Evelyn Pittman, a respected vocalist, educator, director, and composer. The choir became nationally known when it sang at the Chicago Exposition. The choir performed for 12 years during the 1930s and 1940s, and for 14 years the choir's recordings were heard over radio station WKY in Oklahoma City in a show titled *Southern Rivers*, which was carried by NBC for six months. The photograph was taken around 1939. (Courtesy Harold Edwards.)

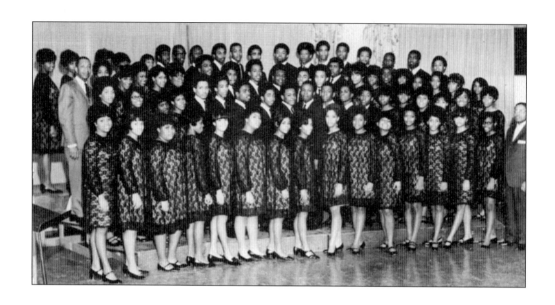

Since the mid-1900s, the Frederick A. Douglass High School music department in Oklahoma City has been famous for producing notable choirs. Zelia Breaux, the first music director at Douglass, left a stellar example for others to follow. During the mid-20th century, there were enough students to have several choirs taught by excellent instructors. Both photographs were taken from the album *Black is Beautiful*, which was recorded in 1970 by Century Records of Oklahoma City. Loretta Hobbs, Donna Davis, and Brenda Seward were accompanists for the choirs. Both choirs were directed by Leroy J. Hicks. (Both courtesy of Charlie Nicholson.)

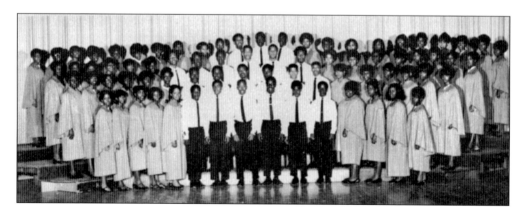

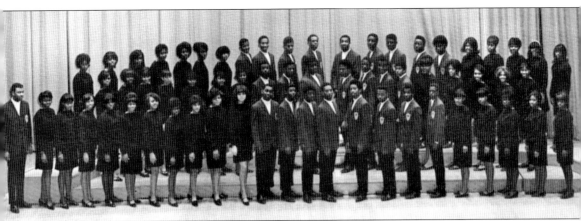

Leonardo E. Debose, a 1956 graduate of Frederick A. Douglass High School, was the music director at Northeast High School Oklahoma City during the 1967–1968 school year. He decided to take the 70-member choir, consisting mostly of juniors and seniors, into Century Studio to record the album *To You with Love*. The album was meant to be a lasting memento conveying the Viking spirit to the graduating seniors, the school, and the community. The 12 songs on the album were a combination of classic spirituals and upbeat love songs accompanied by Leonardo Debose and June McKinney on piano. June, who was well known in music circles in and out of Oklahoma, was married to drummer Temple McKinney, who was part of the Kansas City be-bop circuit in the 1940s. June's mentor was Thad Jones, who loved McKinney's unique chord structure and playing style. The McKinneys had five sons (Temple, Michael, Brian, David, and Marvin) who majored in music and played with famous musicians, including Michael Jackson, Stevie Wonder, Natalie Cole, and many others. (Courtesy of Charlie Nicholson.)

Dr. Kenneth Kilgore, founder and artistic director of the celebrated Ambassadors Concert Choir that started in 1979, was inducted into the Oklahoma Jazz Hall of Fame in 1992. The internationally renowned choir and Dr. Kilgore were special guests of maestro Herrara de la Fuente and the Mineria Symphony Orchestra in Mexico City in 1987 and returned there for two command performances in 1991 and 1994. The Ambassadors received national acclaim in 1996 when they performed on national television during the first anniversary commemorative services of the Oklahoma City bombing of the Alfred Murrah Federal Building. In 2002, the choir performed with Vince Gill for the dedication of the Oklahoma state capitol dome. They have appeared with baritone opera singer Simon Estes and opera singer Leona Mitchell. (At left, courtesy of K. Kilgore; below, Black Liberated Arts Center, Inc.)

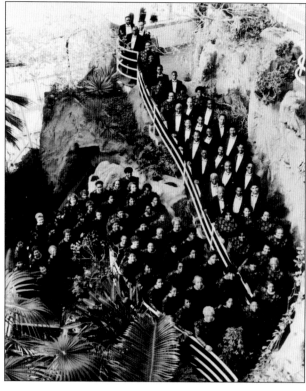

Brenda Johnson (right), a 1969 graduate of Frederick A. Douglass High School, received a bachelor's degree in music education from Oklahoma State University and a master's degree in vocal performance from Oklahoma City University. A college educator, she taught at Langston University, Oklahoma State University, and the University of Central Oklahoma, and she served as minister of music at Olivet Baptist Church. In 2004, Johnson founded and directed the Metropolitan Messiah Choir and Orchestra to perform Handel's *Messiah*, a revival of an idea that began at Douglass High School during the 1950s. The choir and orchestra, composed of local classically trained musicians and vocalists, perform in churches and schools. (At right, courtesy of Brenda Johnson; below, Black Liberated Arts Center, Inc.)

Tyrone Stanley, a musician, composer, vocalist, playwright, and founding director of Wings of Harmony, originally organized the grassroots choir in 1998. The choir performed at churches, civic club functions, dedication programs, and special occasions, including the Oklahoma Governor's Arts Awards ceremony, which is held each year at the capitol. Prior to moving to New York City in 2001, Stanley wrote, directed, and performed in a musical theater production entitled *Souls on Fire*. While in New York, he appeared with the New York City Opera and toured internationally with several shows, including *If This Hat Could Talk* and *Ain't Misbehavin'*. Upon returning to Oklahoma City in April 2007, he revived Wings of Harmony (below) and continued the work of blending community with music. (Above, courtesy John Mayfield; below, Sharon Dean.)

Eight

AND THE BEAT GOES ON

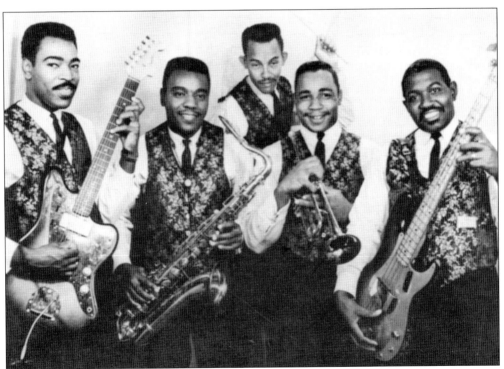

Since 1960, James Walker Sr. has been playing professionally. The first band that he organized, James Walker and the Rocking Robins, played at a number of clubs and bars in Oklahoma City before playing behind Etta James, Bobby "Blue" Bland, O. V. Wright, Joe Turner, Z. Z. Hill, Lowell Fulson, Esther Phillips, and at least a dozen other blues artists. In 2006, he was inducted into the Oklahoma Blues Hall of Fame. (Courtesy of James Walker Sr.)

Guitarist Kelvin Drake has played professionally and traveled since the late 1960s with national artists, including Clarence Carter and Marvin Sease. (Courtesy of Kelvin Drake.)

Booking agents are a major part of a musician's career. Most black musicians in Oklahoma did not seek agency representation. It was the bandleader's responsibility to take care of those matters by whatever means necessary. Under the democratic form of governing, the band voted on the best way to conduct business matters. As times changed, the music world changed as well. Vonzell Solomon, born in Enid, Oklahoma, on November 11, 1961, made her way up the ladder to senior booking agent at the Gary Good Entertainment and Speakers Bureau of Oklahoma City. After living for a while in Kentucky and Florida, she returned to Oklahoma City to meet the challenge of providing services, especially to black bands. Since 2001, she has worked with an impressive list of artists, including Wynton Marsalis, Juanita Ellington (a relative of Duke Ellington), Bill Cosby, and a number of local artists. (Courtesy of Vonzell Solomon.)

John Ford began his music career during the 1970s. He was the bandleader of his first music group, the Funky Music Machine. The photograph below was taken in June 1973 and shows drummer John Ford seated behind vocalist Melissa White. The Funky Music Machine first played the professional stage in April 1976, opening for Cameo and the O'Jays. The group later toured Japan for three months with DES-T3-NE. After the group disbanded, John Ford started another popular band, the 4-1-1 Band, whose reputation was established with excellent, creative performances, including a Motown revue. The 4-1-1 Band opened for and traveled with Kool and the Gang, the Temptations, Clarence Carter, Chubby Checker, Percy Sledge, and Al Green. Pictured above, standing from left to right, are Reggie Jackson (bass), John Ford, Smokey Hondolero, Brian McKinney (keyboards), and Kelvin Drake; vocalist Cara Black is seated. They are favorites at casinos and clubs. (Both courtesy of John Ford.)

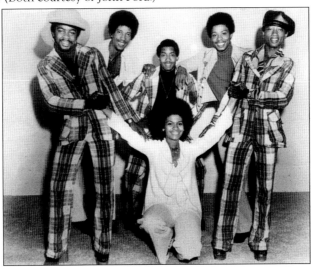

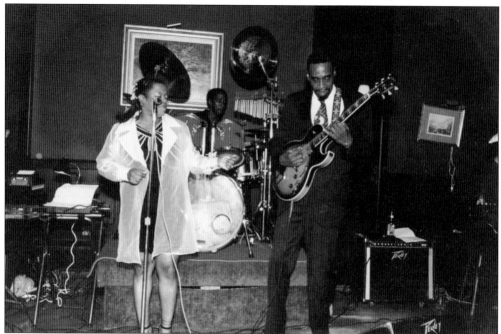

Times have changed, and the beat in music still goes on in Oklahoma City. Local black musicians play with white musicians without eyebrows being raised in clubs and entertainment centers around the city and on Deep Deuce. The concerns and issues of racism are not as prevalent as in former days. The CDS Band (above), led by Delmar Garret on guitar, plays an engagement in the late 1990s at the Waterford Lounge, located in the Marriott Hotel in northwest Oklahoma City. Other band members pictured are Billee Jeane (vocalist) and Mark Ramsey (drums); Garcia Tarver (keyboards) and Karl Wilburn (keyboards) are just off camera to the left and right, respectively. In the late-1990s photograph below, on a sunny afternoon, Beatrice Cole and Company entertains festival lovers with a little jazz in a local park. Pictured are Joe Bob Nelson (guitar), Beatrice Cole (vocals), and Larry Pierce (keyboards). (Both courtesy Walter Taylor.)

Black Liberated Arts Center, Inc., a significant advocate of music and history in Oklahoma City, has experienced change along with the community. Growing from a grassroots arts organization in 1970, the year it was founded, to a replacement for the community's access to arts when arts were removed from the public schools, it has grown up to become a sophisticated, upscale arts organization serving the community. In 2001, Black Liberated Arts Center, Inc.'s founder, Dr. John Smith, president emeritus of Fisk University, flew in from Tampa, Florida, to surprise everyone by appearing at the annual recognition and benefit dinner at the Waterford Hotel. Dr. Smith (left) is seen with William Franklin, president of Black Liberated Arts Center, Inc. in the 1970s. (Courtesy of Black Liberated Arts Center, Inc.)

At left, Oklahoma opera singer Leona Mitchell accepts the Zelia N. Page Breaux Music Award for notable achievements in the field of music on October 6, 2003, at the Petroleum Club in Oklahoma City. Below, native Oklahoman Chester Thompson, a keyboardist and composer for Tower of Power and Carlos Santana for most of his musical career, receives the Charlie Christian Jazz Music Award, which is given to Oklahoma musicians for notable achievement in the field of jazz music, at the Petroleum Club in Oklahoma City in 2004. Awards named for those historical legends of music from the heyday of Deep Deuce include the Evelyn Pittman Music Composers Award, the Zelia N. Page Breaux Music Award, the Charlie Christian Jazz Music Award, and the Ralph Ellison Literary Award. Pictured with Chester are Brenda Davis (left) and Mary Pointer. (Both author's collection.)

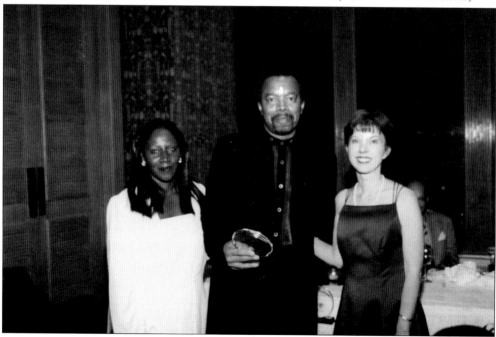

At right, singer Lou Rawls belts out a song at the Civic Center Music Hall in Oklahoma City on October 4, 2002, opening the annual season at the Black Liberated Arts Center, Inc. It was Rawls's last appearance in Oklahoma prior to his death on January 6, 2006. After the concert, patrons and Lou Rawls were given VIP treatment at a reception at the Petroleum Club in Oklahoma City. In the photograph below, Rawls accepts a special recognition award, presented by Anita Arnold, executive director of Black Liberated Arts Center, Inc. (Both photographs by Morris "The Cat" Hinton, courtesy Black Liberated Arts Center, Inc.)

Jaymes Kirksey started playing the piano at age three, as he was taught by his mother, Janet. Taken by his mother to Russian teacher Nellie Asaturyan because of his great talent, Jaymes appeared shortly afterward in his first competition and won second prize. He returned to win 12 first-prize awards at various competitions. Later the fifth-grader entered the Juanita Hubbard Invitational Piano Competition and won, becoming the youngest to win. In 2003, he played at the National Beethoven Society Concert in Oklahoma and for the governor of Oklahoma. He also won the Meinders Piano Competition, becoming the first winner in 15 years to perform the Grieg Piano Concerto with the Oklahoma City Philharmonic. Seen here in 2004, Jaymes Kirksey performs at Black Liberated Arts Center, Inc.'s annual recognition dinner at the Petroleum Club. (Courtesy of Black Liberated Arts Center, Inc.)

In 2005, Jaymes Kirksey, an accomplished violinist, was the only young musician from Oklahoma to be selected to perform Shostakovich's 5th Symphony in the 10th annual National Festival Orchestra under the direction of Benjamin Zander at Carnegie Hall, New York City. Black Liberated Arts Center, Inc. led a fund-raising effort to defray expenses for the trip. In the photograph at right, Kirksey is seen performing at the organization's annual recognition dinner that same year. Below, Jaymes is introduced to pianist Awadagen Pratt following a concert presented by Black Liberated Arts Center, Inc. in February 2005. After listening to the 16-year-old pianist, Pratt immediately took out his business card and encouraged Jaymes to contact him when he got ready to go to college, promising Kirksey a full scholarship to Oberlin College. (Both courtesy of Black Liberated Arts Center, Inc.)

Donna Cox is a versatile vocalist known for performing excellent classical, gospel, and blues concerts in Oklahoma City. She received her bachelor's and master's degrees at the Eastman School of Music in Rochester, New York, and studied for a doctorate in education at Columbia University in New York City. She joined the staff of the University of Oklahoma as a visiting professor of voice in 1994. In February 2007, she appeared with Dave Brubeck in his Mass, *To Hope with the Canterbury Choral Society* at the Civic Center Music Hall in Oklahoma City. Donna performed in festivals, church concerts, and civic programs, and was a member of the Oklahoma Arts Council Touring Roster. In this 2008 photograph, she appears at Black Liberated Arts Center, Inc.'s Soul Food Dinner Theater with a local jazz ensemble. (Courtesy of Black Liberated Arts Center, Inc.)

Drummer Jahruba Lambeth, a regular in a number of Oklahoma City venues that feature drumming performances, made a reputation for himself as an educator conducting workshops for children and adults, as well as teaching drumming lessons and the art of making drums. Lambeth joined the Oklahoma Arts Council's touring program in the 1980s. He is pictured above with one of his unique drums. In the photograph below, he is teaching several children and an unidentified adult how to play African drums in one of Black Liberated Arts Center's after-school programs. Lambeth became a featured headliner in Oklahoma City's annual reggae festival, which was held in Bricktown in the 1990s. (Both courtesy of Black Liberated Arts Center, Inc.)

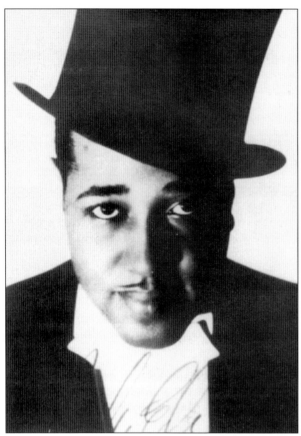

Black Liberated Arts Center, Inc. supports music in many ways, including through art exhibitions about music. In 1999, the organization brought the "Beyond Category: The Musical Genius of Duke Ellington" exhibition to Oklahoma City from the Smithsonian Institution in celebration of the 100th birthday of jazz musician Duke Ellington. The exhibition, displayed at the Omniplex Museum, was open to the public for a month during the Charlie Christian Jazz Festival in July 1999. The event was widely publicized, and Black Liberated Arts Center, Inc. received front-page coverage in the *Daily Oklahoman* for being the first to bring a Smithsonian exhibit to Oklahoma City. These two photographs were part of the traveling exhibition. (Both courtesy of Black Liberated Arts Center, Inc.)

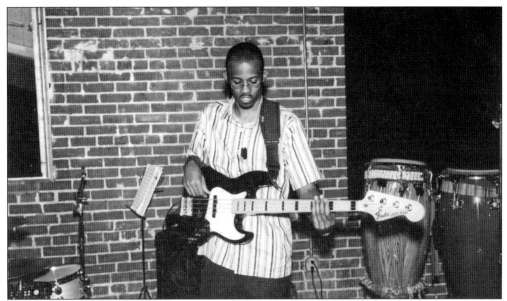

Jeremy Thomas, a master of the B3 organ, caught Oklahoma City jazz lovers' attention in the late 1990s. His regular haunt was the Jazz Lab in Edmond, Oklahoma, though he played all over the state and sometimes out of state. Thomas occasionally thrilled audiences by playing the organ with his feet. When he came on the scene in Oklahoma City, Thomas filled a big void in jazz organ music. Not since the days of tours that brought John Patton, Hank Marr, and Jimmy Smith to Oklahoma City's clubs during the 1960s had anyone surfaced to continue the tradition. In the above photograph, Thomas shows versatility as he plays the guitar in a traditional jam session at the Charlie Christian Jazz Festival in 2005. Below, he performs during the BLAC, Inc.'s annual recognition dinner that same year. (Both courtesy of Black Liberated Arts Center, Inc.)

It was 1990, and Olen Nalley, the first executive director of Black Liberated Arts Center, Inc., stood on Deep Deuce watching the dancing, listening to the music, and approving of what he saw. In the photograph at left, the little man who worked so hard to keep John Smith's dream alive for more than 20 years appears to be looking at the large crowd gathering as the annual Charlie Christian Jazz Festival started. The community always looked forward to the event. Friends and relatives would make a special trip home for it so they could stand on the street corners of Deep Deuce and remember buildings, faces, places, and experiences they had on Deep 2. For most, it was like a family reunion. (Both courtesy of Black Liberated Arts Center, Inc.)

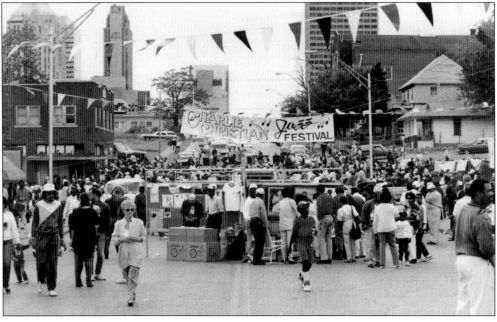

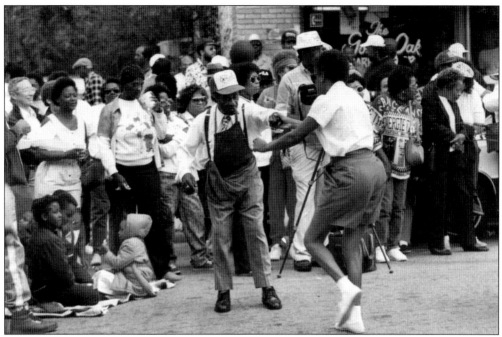

Dancing in the street was part of what made the Charlie Christian Jazz Festival fun. People circled the block for days, beginning two weeks before the event, to see if there were any signs of the festival coming up. They had already made their calls to Black Liberated Arts Center, Inc.'s office beginning in December wanting information about it. Children came to watch, play, eat barbecue, and maybe jump up and down in the inflated moonwalk. These two photographs, taken at the 1990 festival, catch the spirit of the event. It was another way that Black Liberated Arts Center, Inc. could honor the legends that walked, lived, and worked on Second Street at another time. In the photograph above, James "Doughbelly" Brooks, the "godfather" of Second Street, is seen dancing with an unidentified lady. (Both courtesy of Black Liberated Arts Center, Inc.)

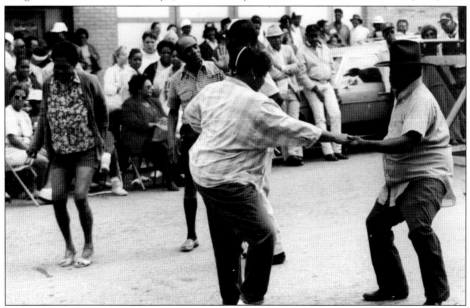

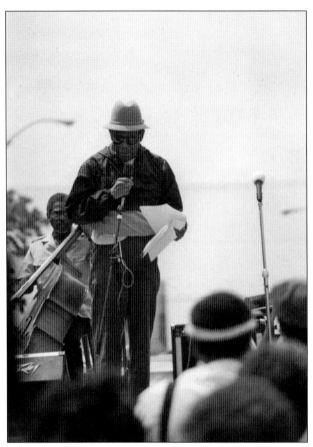

Jimmy Stewart, a local columnist with the *Black Dispatch* who told it all in his weekly, "Jimmy Says" column, stepped up on the stage to the microphone to greet the crowd and remind them of some of the history of Deep Deuce. He knew the history by heart because he had lived it. Singer Roosevelt Turner (below), a 1956 Douglass High School graduate, knew it, too. Roosevelt, staring intently, seemed to be getting ready for a "finger poppin" good time at the biggest block party in Oklahoma City. These photographs were taken during the 1990 Charlie Christian Jazz Festival. (Both courtesy of Black Liberated Arts Center, Inc.)

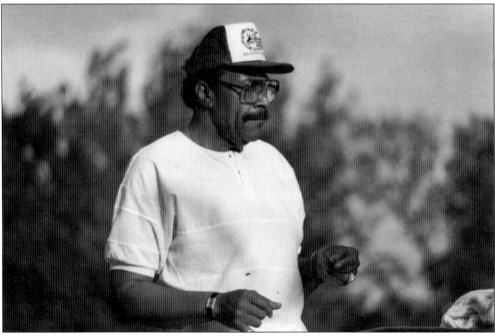

Dignitaries show up for the festival to add their blessings to the day. In the above photograph, Oklahoma state representative Hannah Atkins (right) chats with one of the festival lovers, as Greg Powell (foreground) makes a point during opening day of the 1990 festival. The image below shows the skyline of downtown Oklahoma City rising over Deep Deuce, and the newly erected banner announcing the annual festival reflects the position Charlie Christian was most frequently photographed in with his guitar. The banner has no date because it was meant to be used repeatedly, reflecting the economic condition of Black Liberated Arts Center, Inc. A few banners float in the sky, and chairs on the sidewalk are ready for those who will attend. There are few sponsors, and it is a community affair. (Both courtesy of Black Liberated Arts Center, Inc.)

Change happened noticeably in 2003. Construction was underway on Deep Deuce as new apartment buildings, representing someone's dream other than those who were nostalgic about the Deuce, appeared on Second Street. The festival moved, and folks were upset. That year, Black Liberated Arts Center, Inc. began a long search for a new home for Charlie Christian's memorial celebration. It was held at Remington Park, a horse-racing venue, in 2003. The nostalgia was gone. The festival was then redesigned to preserve traditions of yesteryear. Pictured above in 2008, jazz saxophonist Kirk Whalum (with the hat) and Oklahoma jazz saxophonist Grady Nichols engage in a friendly music competition that had the crowd screaming at Rose State Performing Arts Theater. Below, Freddie Jenkins, a cousin to Charlie Christian, stands next to a Charlie Christian kiosk at the concert. (Both courtesy of Black Liberated Arts Center, Inc.)

The change was complete for Deep Deuce. As the Deep Deuce Apartments at Bricktown began to line the streets of Second Street, articles ran in local newspapers about the cash engine that helped the struggling Bricktown merchants. People drove through Second Street to see the remake of the historic street, occasionally dropping in to look at the hanging pictures of jazz legends at the welcome center. Someone else's dream was taking place, and the realization of that sank deeply into the hearts and minds of those who remembered a different Second Street. Jazz great Wynton Marsalis, who was in town for a concert at the Civic Center Music Hall in September 2001, toured Deep Deuce. Stopping by the welcome center, he demonstrated a few techniques and let a thrilled music student play a few notes on his horn. The photograph, taken by photojournalist Ron Tarver, shows Second Street lined with apartment buildings where Slaughter's Hall stood on the north corner of Northeast Second and Stiles Streets (now Russell M. Perry Avenue). (Courtesy of Black Liberated Arts Center, Inc.)

As Oklahoma City awakened to the stature of Charlie Christian as an international icon, things started to happen. In 2007, a street sign bearing Charlie Christian's name was erected. The name of Byers Street, located near Deep Deuce, was changed to honor Charlie Christian. Peter Broadbent, a musician and author living in Great Britain, flew from England to attend the dedication of the sign and to attend the traditional kick-off in the city council chambers. Later that week, the 4-1-1 Band, seen above, opened the weekend outdoor festival at Regatta Park, located near downtown Oklahoma City and Bricktown, not far from the Bricktown Ballpark and the site of the first Douglass High School. Regatta Park is located in Walnut Grove, which was home to many blacks during the 1920s. (Both courtesy of Black Liberated Arts Center, Inc.)

Levi's Photos

The beat goes on, and Black Liberated Arts Center, Inc., recognizing the importance of music, dance, and history to future Oklahoma City children, continues the work that was started so long ago by the legends of Second Street. Below is a collage of pictures taken at Fredrick A. Douglass High School during a performance of *The Civil Rights Reader* on January 24, 2007. The all-string sextet, to the amazement of faculty and administration, aroused such great response from students that it was talked about for months. The photograph above was taken of Wilson Arts Integrated School students as they leave a performance of the *Marion Anderson Story*. Both musical performances about historical legends were presented by Black Liberated Center, Inc. Photographer Levi McCullough took both images. (Both courtesy of Black Liberated Arts Center, Inc.)

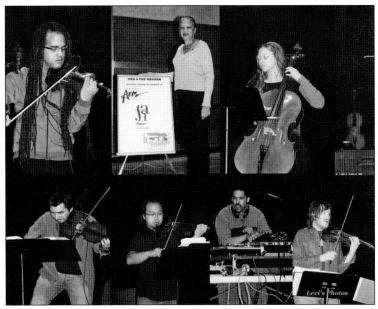

Levi's Photos

www.arcadiapublishing.com

Discover books about the town where you grew up, the cities where your friends and families live, the town where your parents met, or even that retirement spot you've been dreaming about. Our Web site provides history lovers with exclusive deals, advanced notification about new titles, e-mail alerts of author events, and much more.

MADE IN THE USA

Arcadia Publishing, the leading local history publisher in the United States, is committed to making history accessible and meaningful through publishing books that celebrate and preserve the heritage of America's people and places. Consistent with our mission to preserve history on a local level, this book was printed in South Carolina on American-made paper and manufactured entirely in the United States.

This book carries the accredited Forest Stewardship Council (FSC) label and is printed on 100 percent FSC-certified paper. Products carrying the FSC label are independently certified to assure consumers that they come from forests that are managed to meet the social, economic, and ecological needs of present and future generations.

FSC
Mixed Sources
Product group from well-managed forests and other controlled sources

Cert no. SW-COC-001530
www.fsc.org
© 1996 Forest Stewardship Council

Find Your Place in History.